IMAGES
of America

FOREST HILLS CEMETERY

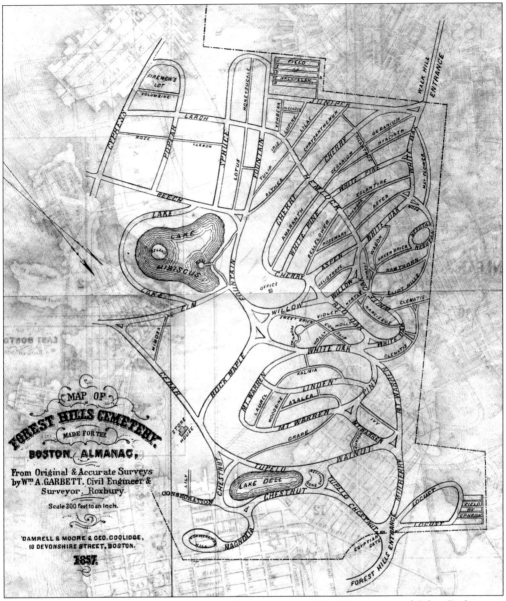

Forest Hills Cemetery was created on the former farms of Joel Seaverns and John Parkinson, from whom the city of Roxbury acquired the land to establish a municipal cemetery in 1848. Seen in this 1857 map that was surveyed by civil engineer William A. Garbett, the land was carved out by Henry Dearborn and city workers to alleviate overcrowded burials in the Eustis Street Burial Ground near Dudley Square in Roxbury.

On the cover: The receiving tomb was designed by the architectural firm of Emerson and Fehmer in Boston and built in 1871 on Consecration Avenue near the main gate. The granite Victorian Gothic Revival building has underground crypts where bodies can be securely held during winter months, awaiting burial or transport elsewhere. (Courtesy of Forest Hill Cemetery.)

IMAGES
of America

FOREST HILLS CEMETERY

Anthony Mitchell Sammarco

ARCADIA
PUBLISHING

Published by Arcadia Publishing
Charleston SC, Chicago IL, Portsmouth NH, San Francisco CA

Printed in the United States of America

Library of Congress Control Number: 2008923398

For all general information contact Arcadia Publishing at:
Telephone 843-853-2070
Fax 843-853-0044
E-mail sales@arcadiapublishing.com
For customer service and orders:
Toll-Free 1-888-313-2665

Visit us on the Internet at www.arcadiapublishing.com

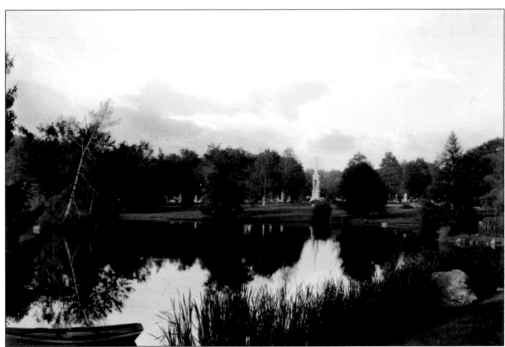

The bucolic and peaceful landscape of Forest Hills Cemetery is highly evident in this picturesque parklike image from the late-19th century. Lake Hibiscus was originally a smaller, spring-fed natural pond that was enlarged to a four-acre lake with three islands in the 1850s. With mature specimen trees dotting the landscape, Henry Dearborn's vision of a rural cemetery was admirably achieved.

CONTENTS

ACKNOWLEDGMENTS

I would like to thank the trustees of the Forest Hills Educational Trust and the trustees of the Forest Hills Cemetery, and the staff of Forest Hills Cemetery and the Forest Hills Educational Trust, all of whom have been extremely helpful in the researching and writing of this book.

I would also like to thank: Sandy Adams; Archdiocese of Boston, Robert Johnson-Lally; the Art Institute of Chicago; Boston Athenaeum, Sally Pierce; Boston Public Library, Aaron Schmidt; Bowdoin College Museum of Art; Carleton-Willard Village, Stephanie Smith; Joe Cedrone, who can always find with grace the book or paper I misplaced; Elise Ciregna; Edith Clifford; Nini Colmore; William Dillon; Olivia Grant Dybing; Kevin Fitzgerald; Forbes House Museum, Christine Sullivan; the late Walter S. Fox, Jr.; Helen Hannon; Erling Hanson; Nancy Foss Heath; Jamaica Plain Historical Society; *The Pilot*, Gregory L. Tracy; Mary Maresca; Jane Whitney Marshall; Al Maze; Cecily Miller; George Milley; Museum of Fine Arts, Erin Schleigh; Ellen Ochs; Barbara Owen; Susan W. Paine; William H. Pear, II; Fran Perkins and Charlie Rosenberg; Lilian Randall; Christopher and Kita Reece; Erin Rocha; Dennis Ryan; Schlesinger Library, Diana Carey; William O. Taylor, II; Vincent Tocco, Jr.; Archives and Special Collections, Healey Library, University of Massachusetts Boston, Elizabeth Mock; Stephen Walker, South End Photo Lab; Thomas M. Whitney; Susan Wilson; and James Preston Wysong.

All images appear courtesy of the archives of Forest Hills Cemetery, unless otherwise noted.

INTRODUCTION

He That Keepeth Thee Will Not Slumber

Henry Dearborn laid out Forest Hills Cemetery. He had impressive credentials, as in 1829, he was among the founders and the first president of the Massachusetts Horticultural Society, and he laid out Mount Auburn Cemetery, a rural cemetery north of Boston. Opened in 1831, Mount Auburn Cemetery was the progenitor of the picturesque rural cemetery movement in the United States that closely followed the example of Pere La Chaise, a cemetery founded in 1804 in Paris. Like its predecessor, Forest Hills Cemetery was envisioned as a very different place from the colonial burying grounds throughout the city of Boston, addressing the public health problems and concerns of these overcrowded places of burial. Rural cemeteries were laid out on lands undulating in different topography, including dells, valleys, and curvilinear carriage roads and paths lined with a variety of trees and shrubs, all of which created not just a place of burial but an arboretum or park to be enjoyed by family and friends visiting their departed ones.

The Seaverns farm was in the area of Canterbury, was bounded by Morton, Canterbury, and Walk Hill Streets, and was a short distance from Washington Street, the old Providence Turnpike that connected Boston and Providence, Rhode Island. The farm was selected because of its "varied natural features, which included hills, valleys, lakes and diverse types of vegetation ranging from dense woodland to open fields." It was increased in size the same year when the farm of John Parkinson was purchased, bringing the total to 71 acres. Roxbury had been named for the large outcropping of stone and ledge throughout the area that was to become immortalized by Oliver Wendell Holmes in his poem "The Dorchester Giant" and to be henceforth known as Roxbury puddingstone.

Since its founding, the impressiveness of the buildings at Forest Hills has made it a special place. In 1848, Dearborn designed an Egyptian Revival gateway that served as the entrance on Forest Hills Avenue for almost two decades until it was replaced by the present Gothic Revival Roxbury puddingstone and sandstone designed by Charles W. Panter and built in 1865. The entrance gate was flanked by two pedestrian gates and two square gatehouses, which now serve as public restrooms. A two-story Gothic Revival gatehouse was designed by Gridley J. Fox Bryant and Louis P. Rogers and built in 1868 on Forest Hills Avenue. Just inside the cemetery, a Gothic Revival receiving tomb designed by William Ralph Emerson and Carl Fehmer was built in 1871. The erection of the bell tower in 1876 made a dramatic impact, as it rose 100 feet from a massive outcropping of Roxbury puddingstone known as Snowflake Hill. The Gothic Revival Forsyth Chapel was designed by the Boston architectural firm of Van Brundt and Howe and was

completed in 1884, with a large office building added to the structure in 1921. Off Walk Hill Street is the crematorium, designed by Ludvig S. Ipsen and built in 1893 by the Massachusetts Cremation Society as the first crematory in New England. Sold to Forest Hills Cemetery in 1925, the crematory has columbaria for those choosing cremation rather than full burial, as well as the Lucy Stone and Pitman Chapels for memorial services. Each of these buildings, impressive in their individuality, contribute to the impressiveness of Forest Hills Cemetery.

As there is so much history and so many persons of note associated with Forest Hills Cemetery, it is impossible to include all aspects. It is hoped by the author that this photographic volume can convey in some small measure the myriad aspects of history, landscape design, and biographies that make this a truly special place.

One

Dearborn's Vision

Calm woodland shade! We here would lay
The ashes of our loved away;
And come at length ourselves to sleep,
Where thou wilt peaceful vigil keep.

In the creation of Forest Hills, Gen. Henry A. S. Dearborn, with his own hand, "marked out the winding avenues and shaded paths, observing how each should reveal some beauty while making available the gentle slopes or the rugged steeps as resting places for the dead. . . . He modeled the imposing gateway at the principal entrance; he projected the chief adornments, and in a word, he stamped his own idea upon the cemetery in all the varied forms with which art has developed and increased the beauties of nature, an untiring industry, and a pious regard for the claims of the dead. Hardly was there a sign that he even desired to associate his name so intimately with the sacred shades of Forest Hills . . . though such an ambition were no unworthy one. But he labored rather for the love of his work, for the honor of the dead and the solace of the living." In some ways, Victorians believed that "nature offered special keys for unlocking the mysteries of life and death."

In essence, Forest Hills Cemetery began in 1848 with what was then "a radical plan for burial and commemoration that linked nature, landscape design, and horticulture with art and architecture," according to a history of the cemetery.

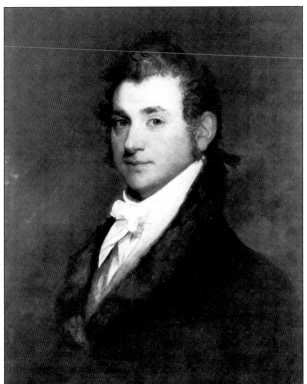

Henry Dearborn (1783–1851) laid out Forest Hills Cemetery in 1848. A graduate of the College of William and Mary, Dearborn studied law and served as collector of the port of Boston, a representative and state senator, as well as a member of the United States Congress. He served as the first president of the Massachusetts Horticultural Society and as mayor of Roxbury from 1847 to 1851. (Courtesy of the Bowdoin College Museum of Art.)

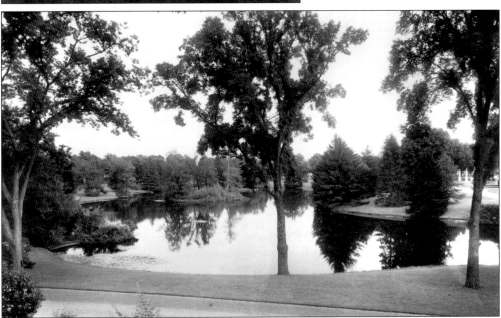

Lake Hibiscus was originally a smaller, spring-fed natural pond, but in 1852, it was greatly enlarged to a four-acre lake lined with stone, and its undulating shoreline was curbed in granite. In the center of the mirrorlike lake is Swan Island, completed in 1861. It is still a refuge for a variety of swans, geese, and ducks, as well as a parklike landscape of shade trees over a century and a half later.

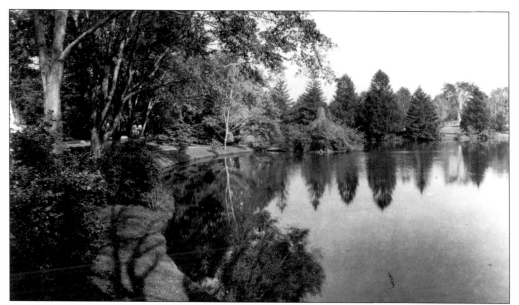

At the solemn consecration ceremony on June 28, 1848, Rev. George Putnam (1807–1878) of Roxbury praised the new cemetery as a place of "wooded heights and shaded valleys, grass slopes, little lake of living water . . . the oak, the walnut and the birch, a solemn grove of evergreens along the southern border . . . jagged piles of old convulsions and a wild war of the elements; and the mosses on their sides and the gnarled trees in their crevices are the emblems of present stability and peace."

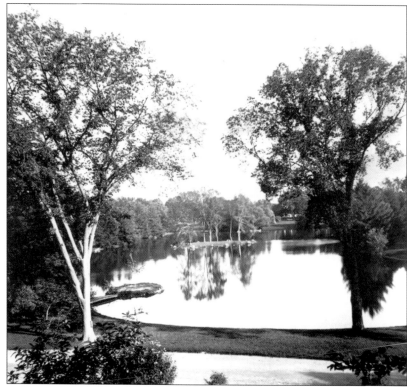

Seen between two shade trees, Lake Hibiscus's undulating edges and the mirrorlike sheet of water combine to achieve the ideals of the rural cemetery of the 19th century through peaceful and serene vistas.

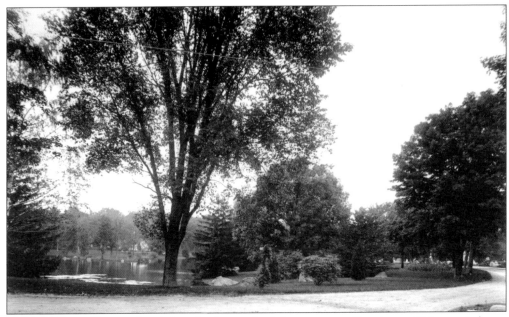

In 1872, *Boston Illustrated* said that the "grounds of the cemetery, like those of Mount Auburn, are exceedingly picturesque, the variety of hill and dale, greensward, thickets of trees, pleasant sheets of water, and rocky eminences, making the place an exceedingly attractive spot to wander and read the story of lives that are spent. And the hand of art has added much to the natural beauty of the place."

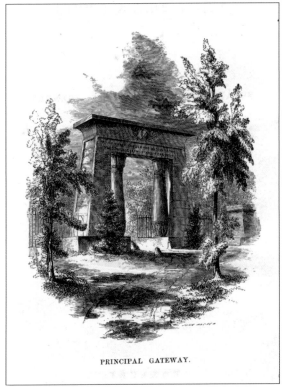

PRINCIPAL GATEWAY.

The original gateway at Forest Hills Cemetery was designed by Henry Dearborn and was a wood Egyptian Revival entablature, having two freestanding columns with Lotus Leaf capitals. Said by Dearborn to have been "copied from the ancient portico at Garsery on the Upper Nile," it was painted and sanded to give it the appearance of the more expensive and durable granite.

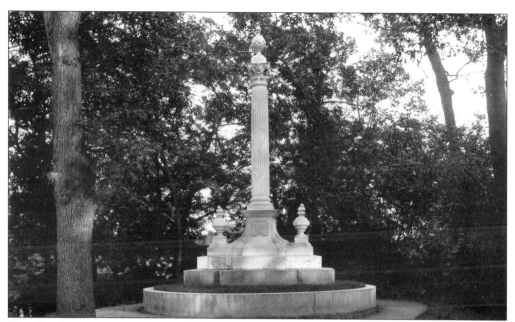

The Dearborn monument is a simple, 16-foot white marble Corinthian column flanked by matching urns. It was erected by Dearborn to mark the graves of his parents, Henry and Dorcas Marble Dearborn, who were interred at Forest Hills Cemetery as the first and second burials. They were originally buried at Mount Auburn Cemetery but were moved upon the founding of Forest Hills Cemetery.

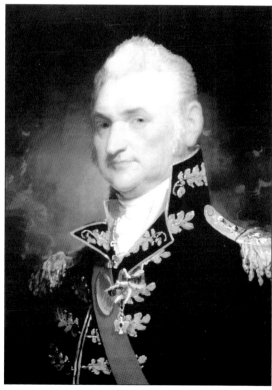

Maj. Gen. Henry Dearborn (1751–1829) was a physician, statesman, and veteran of both the American Revolutionary War and the War of 1812. He served as secretary of war under Pres. Thomas Jefferson and later as minister plenipotentiary to Portugal from 1822 to 1824 under Pres. James Monroe. He and his second wife, Dorcas Osgood Marble Dearborn (1752–1810), were interred on Sweet Briar Path at the new Forest Hills Cemetery in 1848. (Courtesy of the Art Institute of Chicago.)

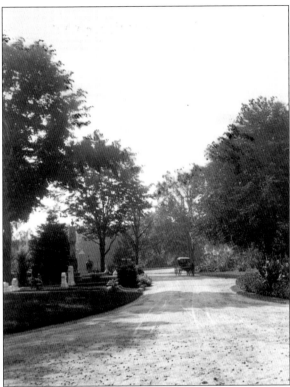

A horse-drawn carriage pauses on a carriage path in the late 19th century. On the left are monuments set on family lots of varying heights, materials, and grandeur. Often family and friends drove out to Forest Hills Cemetery to enjoy the parklike grounds, the magnificent shade trees, and flowering shrubs and funereal monuments.

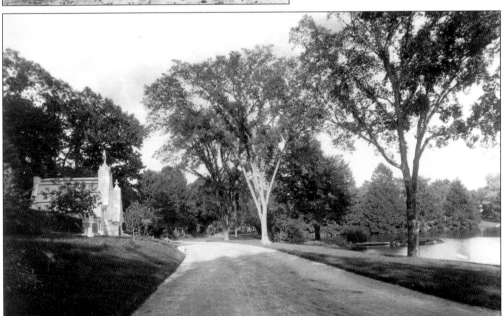

The beauty of this rural cemetery was incredible, but Francis S. Drake, author in 1878 of *The Town of Roxbury: Its Memorable Persons and Places*, said that much of "its territory, naturally picturesque and diversified, and now tastefully embellished, was wild land not long ago, and . . . was almost valueless, save as the source of the town's fuel supply for its schools and its ministers."

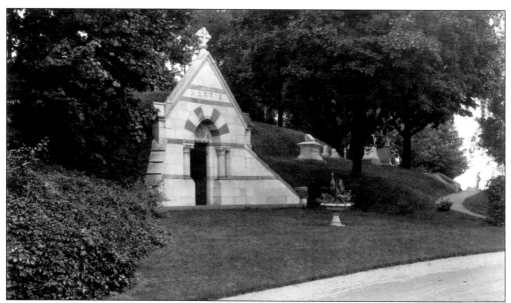

The Harris Mausoleum is on Consecration Avenue and is set into the side of Consecration Hill. Horatio Harris (1821–1876) and his wife Eunice Crehore Harris lived on Walnut Avenue in Roxbury, and after their deaths their estate was developed as Horatio Harris Park and Harriswood Crescent, an impressive row of Queen Anne Revival houses built in 1890. Horatio was a commission merchant, and proprietor of the Adams, Oxnard and Continental Sugar Refineries. He was one of the originators, and a director, of the Metropolitan Street Railway in Roxbury.

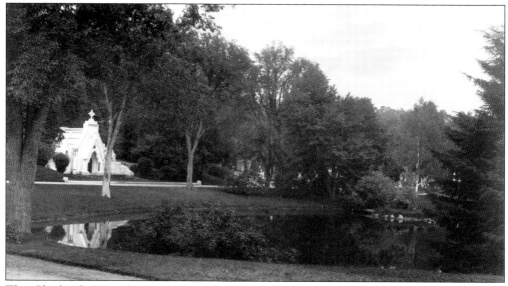

The Chadwick Mausoleum is a large limestone Gothic Revival tomb designed by William Gibbons Preston (1842–1910) and built on Fountain Avenue across from Lake Hibiscus. Joseph Houghton Chadwick (1827–1902) was president of the Chadwick Lead Works in Boston and was a founding trustee of Boston University and served as president and trustee of Forest Hills Cemetery. Nestled into the sloped hill in the rear, the mausoleum is an elegant churchlike structure with a heavy grilled lead door bearing the name Chadwick.

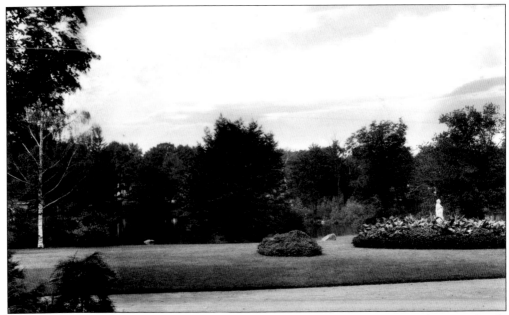

Seen from Lake Avenue, the lush lawn abutting Lake Hibiscus was not only meticulously maintained but also picturesquely dotted with variously sized outcroppings of Roxbury puddingstone. On the right is a large garden bed planted with cannas, tropicals, and other plants cultivated in the extensive greenhouses, creating vivid color and texture in the ideal of the rural cemetery.

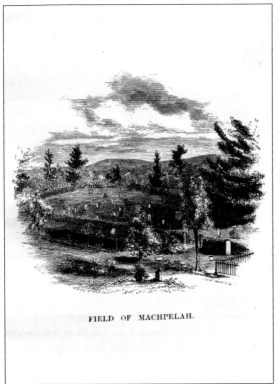

FIELD OF MACHPELAH.

The Field of Machpelah was laid out in 1851 as an area of single-lot graves between Fountain, Juniper, and Cupressus Avenues. The biblical name of Machpelah derives from the subterranean Caves of the Patriarchs in the ancient city of Hebron. Considered one of the holiest sites, it is the supposed burial place of Adam and Eve. The field at Forest Hills, laid out only a few years after the cemetery was opened, allowed for a wide swath of Boston Victorian social classes to be buried here.

Two

HORTICULTURAL MARVEL

A man does not plant a tree for himself; he plants it for posterity.
—Alexander Smith

Noah Webster describes horticulture as the "art or science of growing flowers, fruits and vegetable." However, at Forest Hills Cemetery the aspect of horticulture was to take on a new connotation with the development and careful nurturing of a rural cemetery. Beginning in 1848, the natural topography of Forest Hills was recreated, embellished, and enhanced by Henry A. S. Dearborn, Daniel Brims, and a dedicated cadre of gardeners whose accomplishment is still appreciated more than a century and a half later. These early horticulturalists shaped the open farmland and rocky hills into a rugged, yet elegant landscape, and to enhance a variety of native species such as oak, maple, and chestnut trees, they planted many diverse species of trees such as weeping hemlocks, European weeping beeches, ginkgos, and Japanese umbrella pines. These plantings helped to create a picturesque rural cemetery that became a destination for the public offering a way to embrace and reconnect with nature.

The notion of a rural garden cemetery was that the beautiful and harmonious environment, created by skilled design and horticulture, might have a consoling effect on mourners, helping them in their grief. In fact, Andrew Jackson Downing (1815–1852) wrote in his book *Rural Essays* to "plant spacious parks in your cities, and unloose their gates as wide as the gates of morning to the whole people." Thus, the parklike aspect of Forest Hills was important in that it was considered essential to its success as a place for burial and one of remembrance. Francis S. Drake, historian of Roxbury, said that, "Hill and dale, lake and grove, picturesque rocks, cool grottoes, fragrant flower-beds, and ever-varying landscapes render this an exceedingly attractive spot; and a saunter through its principal avenues, with their beautiful monuments and interesting inscriptions, it is a pleasure long to be remembered."

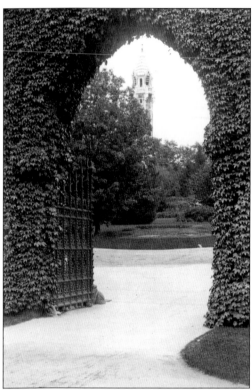

The bell tower, seen through an ivy-covered archway of the gateway designed by Charles W. Panter, is an impressive feature to see when approaching Forest Hills Cemetery. From its lofty eminence atop Snowflake Hill, the panoramic view from the four dormers below the stepped roof is nothing less than spectacular, and one can see far past the bucolic cemetery to many surrounding towns.

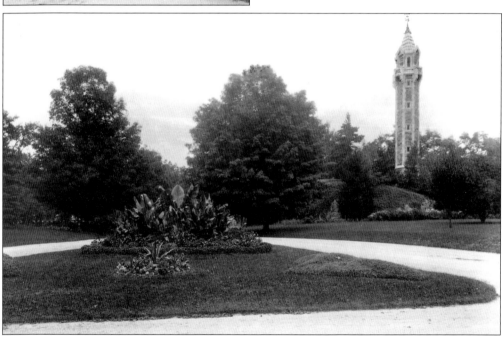

The bell tower is prominently sited on an outcropping of Roxbury puddingstone and rises high above the magnificently landscaped grounds seen near the entrance. In the foreground is a large, bedded garden of annuals and exotic plants that creates an impressive and attractive Victorian-era display.

18

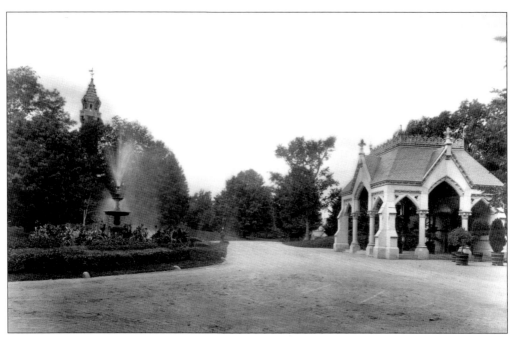

Consecration Avenue leads from the gateway to the center of Forest Hills Cemetery. The receiving tomb, on the right, overlooks the center garden with its playing fountain. The original receiving tomb was on the site of this garden. *King's Handbook of Boston* states, "Miles of winding avenues and footpaths lead over hills and through little valleys and glades."

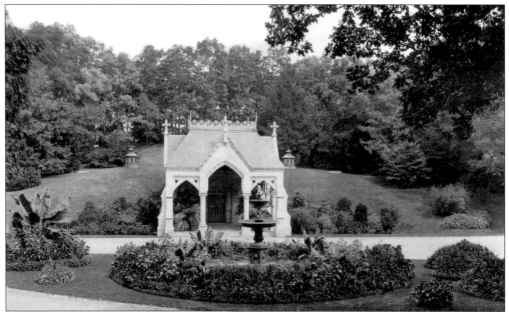

The receiving tomb is an impressive Gothic Revival structure built into Consecration Hill, seen rising behind it with twin brick and cast-iron ventilators on either side. The central arched opening has smaller openings with trefoil cutouts on either side and a magnificent French encaustic tile floor. Seen on the entrance porch are huge palm trees, placed there during the summer months.

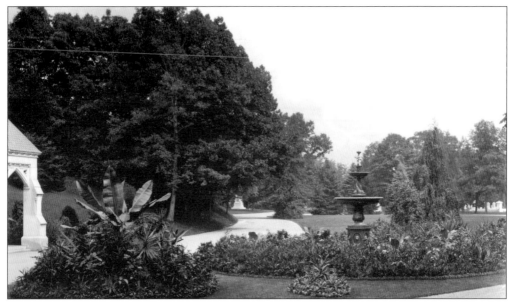

Looking south on Consecration Avenue, the bedded gardens seen near the entrance to the cemetery were as impressive as the open, rolled lawns that drew one's eye to the beginning of the lots in the distance; the large irregular oval between Tupelo and Consecration Avenues had once been Lake Dell. The open area as one entered the cemetery through the main gate was impressive, with lush lawns dotted by outcroppings of Roxbury puddingstone and roads leading into the cemetery on both sides.

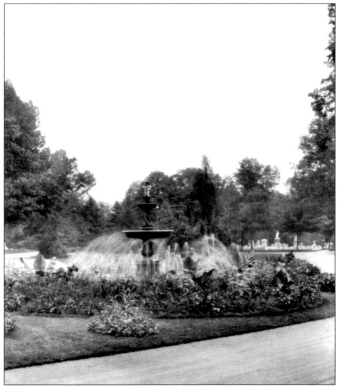

The three level cast-iron fountain in the center of the bedded garden was impressive, with an octagonal base embellished by lion's heads, a trio of dolphins entwined on the center shaft, and two puttees embracing the shaft at the top. The fountain played not only cascading water but also jets of water sprayed from the edge of the circular pool.

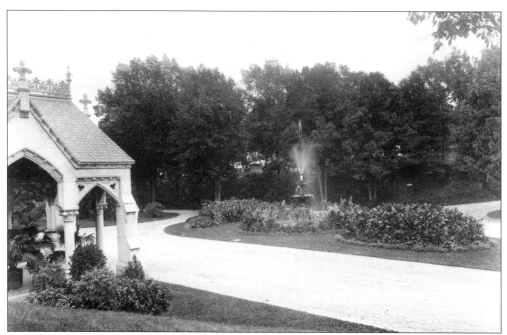

Looking from the slope of Consecration Hill behind the receiving tomb, the central garden was well tended and charming, with the fountain playing water throughout the day. This garden creates a colorful impact and recalls the 19th-century landscape. One can glimpse family monuments through the trees in the distance.

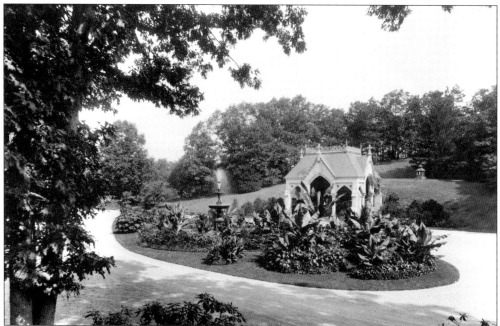

Originally the site of the first receiving tomb, the oval was between curvilinear paths along with the irregularly shaped beds that made for an interesting use of the topography. Since its inception, Forest Hills Cemetery has had a myriad of topographical features, such as scenic vistas, dells, valleys, and landscapes, creating not just interest but also a multitude of uses.

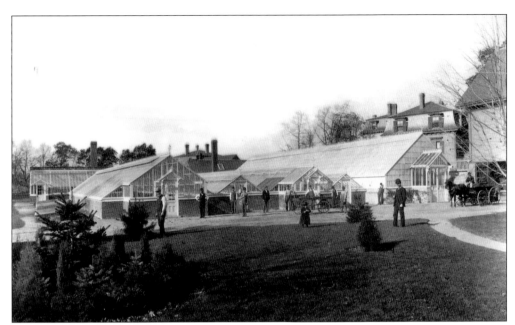

The greenhouses were a series of different-sized glass houses that had been added to and rebuilt throughout the late 19th century. Located just behind Forsyth Chapel and the office, they were tended by numerous gardeners who not only grew plants and flowers from seeds but also nurtured exotic plants that were stored during the winter months. Gardeners and wagons stand in the forecourt, and a small-bedded garden with evergreen is on the far left.

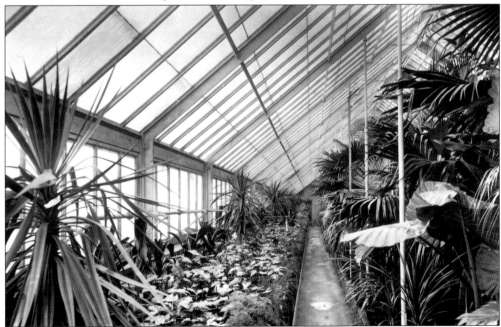

The interior of one of the greenhouses had exotic plants, such as palm trees, banana leaf plants, yucca, and ferns, which awaited transplant to the many bedded gardens the gardeners created every spring. The lavish full-blown Victorian displays planted a century ago would be not just hard to replicate but also to maintain.

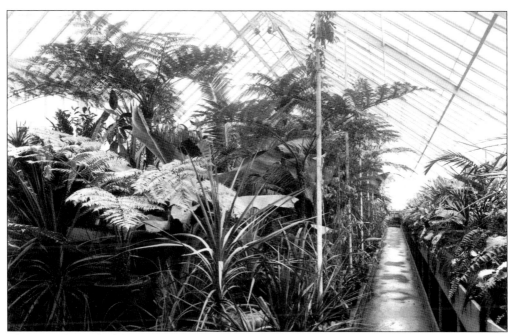

This greenhouse had ferns of all sizes and varieties that were a pleasant backdrop to a cold winter day as gardeners and visitors strolled along the walkways. Wintered over in these extensive glass houses, the gardeners created exotic and lush plantings using these ferns to embellish and beautify the numerous bedded gardens at the cemetery.

By the late 19th century, the lavish floral plantings at Forest Hills assumed the gusto and exuberance of the Victorian period, often being full blown and certainly over the top. Here, gardeners have planted a large flower bed, and with wires as guides, they have trained ivy to create a virtual crown in the jewel-tone colors of the plants. These displays took tremendous effort and maintenance but were one of the major reasons people selected lots in this rural cemetery. (Courtesy of the Jamaica Plain Historical Society.)

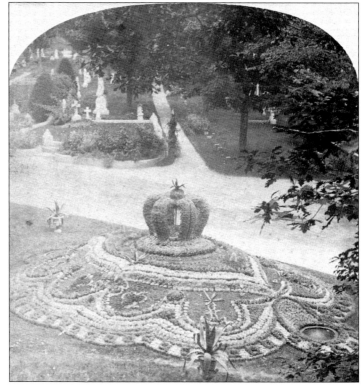

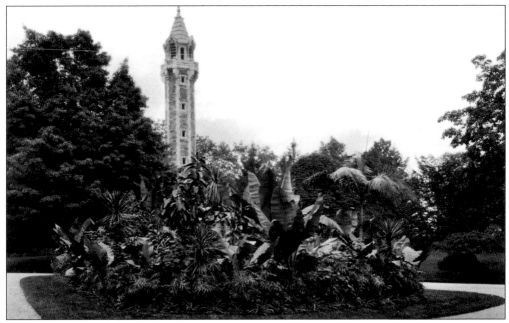

The gardeners at Forest Hills were skillful in nurturing and encouraging the growth of plants in the greenhouses during the winter months. When set out in the spring, lavish plantings of tropicals and annuals created dramatic beds. This flower bed was encircled by grass, in the shadow of the bell tower.

Looking from the bedded garden at the edge of Tupelo and Mulberry Avenues, the porte cochere of Forsyth Chapel can be seen in the distance. This area has remained open since 1848 and still has attractive plantings that re-create the Victorian-period garden beds.

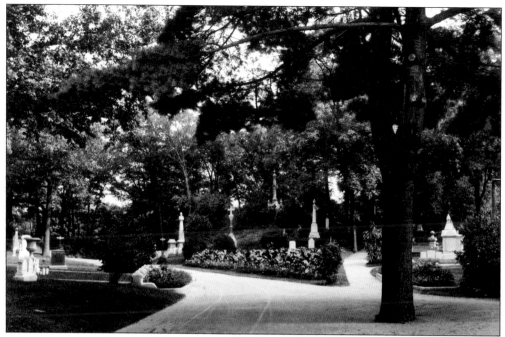

This triangular garden was planted at the foot of Mount Dearborn at the junction of White Oak Avenue (left) and Red Oak Avenue, with the Dearborn monument seen through the trees in the center, surmounting the hill.

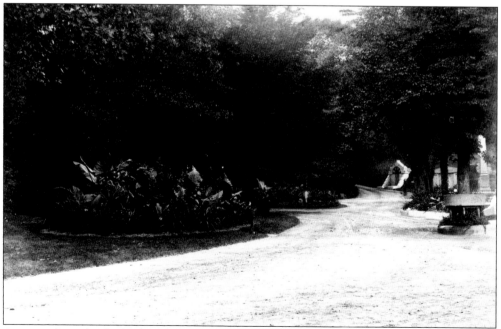

A series of circular, bedded gardens can be seen on the left, with curbed lots on the right full of flowers, plants, and trees. In the distance is the Fellner and Cartwright mausoleums on White Oak Avenue. These plantings were intended to compliment and reflect the headstones and monuments of the surrounding area while adding color and texture.

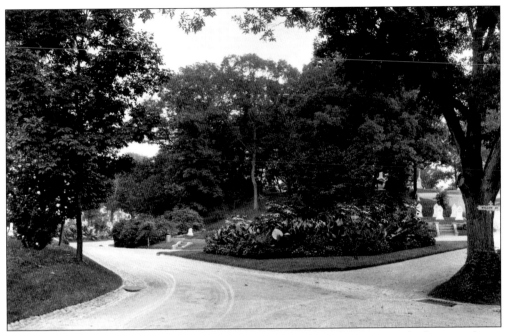

At the junction of Cherry and Willow Avenues is a large garden composed of exotic plants. *King's Handbook of Boston* said of the cemetery in 1878 that in "the summer a profusion of flowers and shrubs is seen on every hand. There are pretty little lakes, handsome rural groves, and on the heights one catches glimpses of beautiful distant scenery."

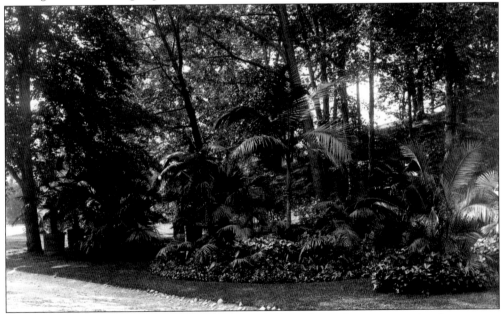

Exotic palm trees in wooden tubs were placed throughout the cemetery in the summer months. These palm trees could be 10 to 15 feet in height and created a semitropical garden in old-fashioned New England. The gardeners were well trained and created many different gardens from annuals and perennials to ones like this, composed of exotic plants that were replanted year after year.

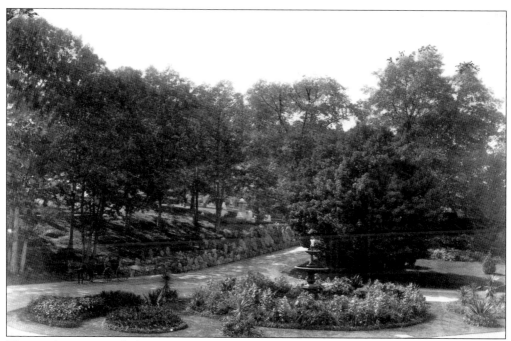

The rural cemetery ideal was never more evident than in this scene from around 1895. The gently rolling topography with a rockery of broken Roxbury puddingstone pieces on the center left acts as a foil to the manicured bedded garden in the center.

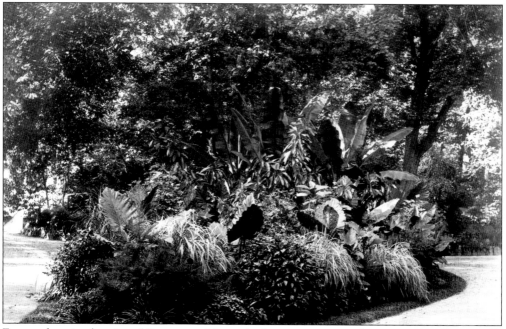

Few gardens in the city of Boston could match the interesting gardens created at Forest Hills Cemetery. Here various palms, banana leaf trees, and other exotics created a juxtaposition of texture, leaf pattern, and color. The Boston Public Garden had lavish displays of tropical plants and cactus in the late 19th century, similar to those planted at Forest Hills Cemetery.

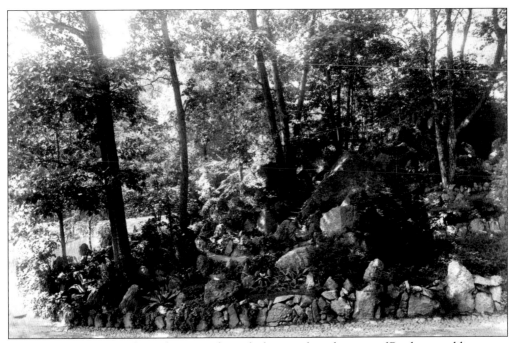

A rockery garden created visual interest through the use of rough pieces of Roxbury puddingstone for beds, curbs, and partially hidden stairs leading into a shade garden.

The rockery along Asphodel Path was created from pieces of Roxbury puddingstone. The stone pieces were placed in such a way as to retain the slope and to create a visually interesting aspect to burial lots. Here, the lot of Edward Newton Perkins of Pinebank and the identical limestone crosses of Perkins family members overlook Lake Hibiscus in one of the most panoramic and impressive vistas at Forest Hills Cemetery.

Three

THE BUILDINGS

Good buildings come from good people, and all problems are solved by good design.
—Stephen Gardiner

As Henry A. S. Dearborn said in 1847, "Let us then emulate the enlightened and pious, the good and great, the affectionate and generous, the kind and the magnanimous of all other nations and ages, that were most distinguished for their advancement in civilization, and enable our fellow citizens to pay all possible respect and honor to the remains of those whom they loved and revered when living." Thus, the rural cemetery was not just a link to nature, landscape design, and horticulture, but also a link to architecture that embraced and enhanced the rural ideal, while serving a very necessary function.

The buildings, gateways, fences, and assorted structures erected at Forest Hills Cemetery were built for intended purposes, but their design and materials were reflective of Dearborn's vision of integrating the ideal of romantic landscape design with symbolically appropriate architecture. The first thing seen by those arriving via Forest Hills Avenue was the gateway, originally a wood Egyptian Revival gateway that was replaced by a grander one of Roxbury puddingstone in 1865. This was an aesthetic experience and in some ways must have reassured mourners that this was a sacred place that was to embrace and offer a consoling garden sanctuary. Embracing the wooded landscape and the rough outcropping of Roxbury puddingstone rather than eliminating them, the cemetery evolved as a distinctive and unique interpretation of a rural cemetery.

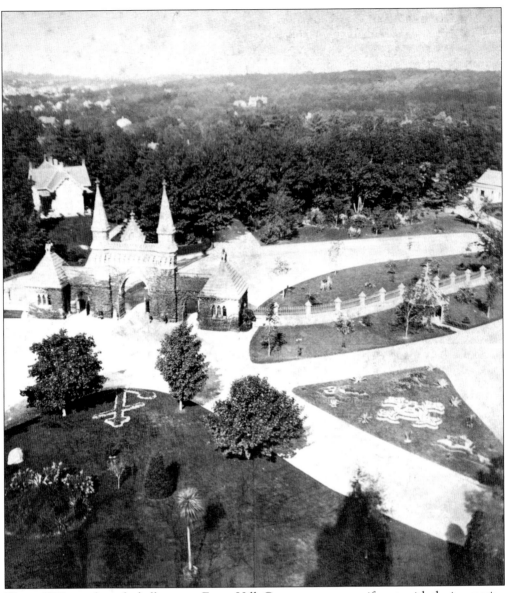

This c. 1876 view from the bell tower at Forest Hills Cemetery was magnificent, with the impressive Roxbury puddingstone gate designed by Charles W. Panter in the center flanked by the matching gatehouses. The forecourt in front of the gateway is open with carriage paths leading to varying points within the cemetery. Notice the huge anchor in the foreground, completely composed of colorful annuals and flowering plants, with geometric designs on the right in a triangular bed. The lavish use of trees, shrubs, and bedded-out flowers created an impressive display that elicited much admiration in the Victorian period. (Author's collection.)

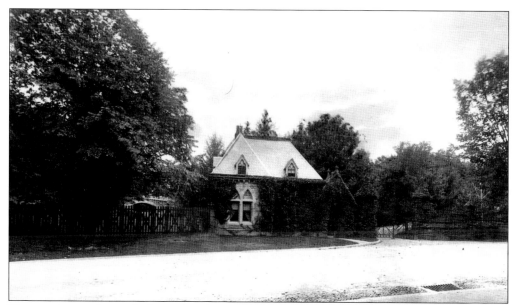

The gatehouse, located along the drive known as Forest Hills Avenue, was designed by Gridley J. Fox Bryant (1816–1899) and Louis P. Rogers (1838–1905) and built in 1868 adjacent to a secondary entrance to the cemetery. A charming two-story Gothic Revival cottage, it is built of Roxbury puddingstone and buff sandstone with a steeply pitched dormered roof and bands of red and black slate. Built as the gatekeeper's residence, it is today leased by the trustees of the cemetery as a private residence.

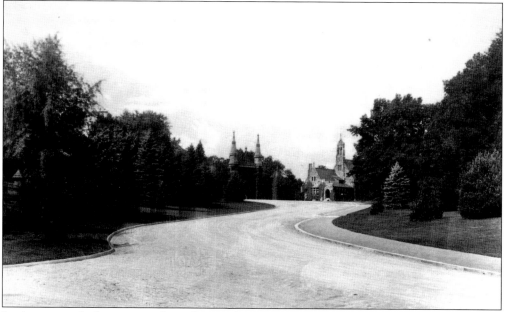

Looking towards the entrance from the curvilinear Forest Hills Avenue, the gateway and Forsyth Chapel can be seen in the center flanked by shade trees and evergreens. The sandstone used for the gateway was carved by Michael Killian, and the ornamental ironwork was wrought by Edward Meany. The entire assemblage of sandstone, puddingstone, and wrought iron creates an impressive and dramatic entrance to the cemetery.

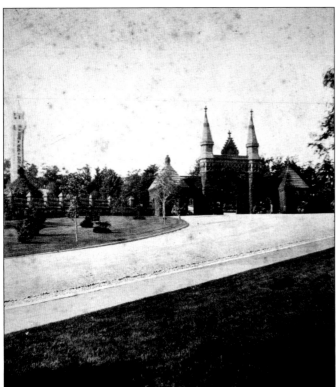

The bell tower rises majestically from the Roxbury puddingstone outcroppings of Snowflake Hill, overlooking the gateway. Forest Hills Avenue was initially paved with crushed stone, much of it from excavations in the cemetery, with cobblestone gutters on either side. Notice the young trees planted along the avenue, with the odd piece of Roxbury puddingstone dotting the landscape. (Author's collection.)

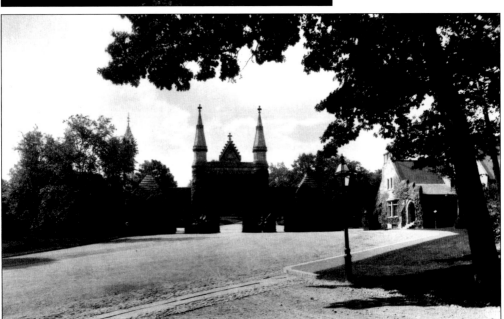

Charles W. Panter of Brookline designed the monumentally impressive gateway, which was completed in July 1865. Built of Roxbury puddingstone and buff sandstone with two conical spires and a central stone pediment, it has flanking square gatehouses with steeply pitched sandstone roofs. Above the central gate is the biblical inscription, "He that keepeth thee will not slumber."

Boston Illustrated described the gateway in 1872 as, "a very elegant, costly, and imposing structure of Roxbury stone and Caledonia freestone." The lush ivy clinging to the stone in the late 19th century obscured the biblical inscriptions. In golden letters is, "I Am The Resurrection And The Life." (Author's collection.)

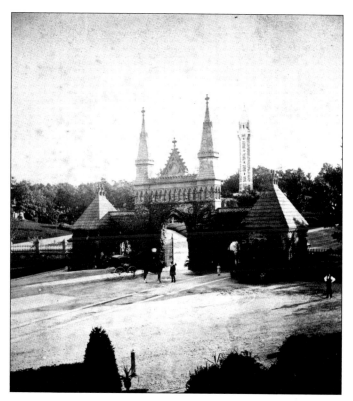

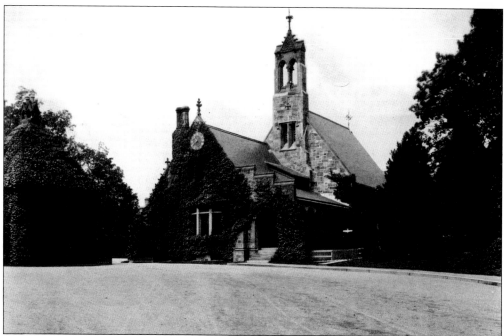

Forsyth Chapel and the office were designed by Henry Van Brundt (1832–1903) and Frank M. Howe (1849–1909) and built in 1884. Van Brundt and Howe was a prominent architectural firm that designed an impressive structure to the right of the gateway.

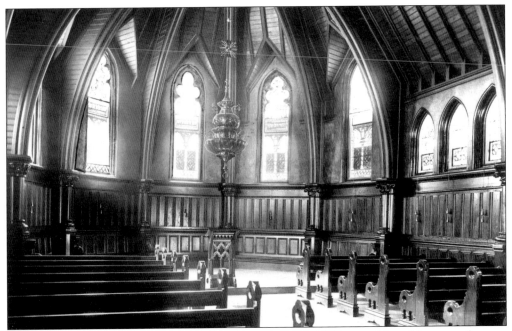

Forsyth Chapel was the gift of James Bennett Forsyth (1850–1909), a wealthy rubber manufacturer who also founded and endowed the Forsyth Dental Clinic in Boston. The interior of the chapel is sheathed in rich oak paneling, and it has ribbed buttresses that create a series of arched soaring niches, which have stained-glass windows set between.

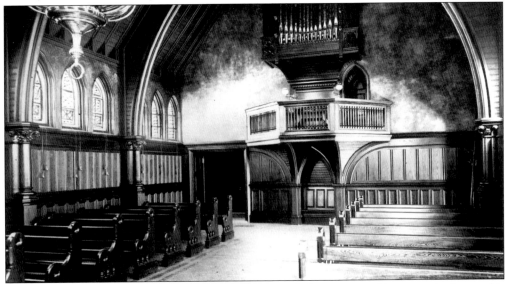

Looking towards the rear of Forsyth Chapel, the organ loft is supported by two oak piers and is encased by a balustrade. The organ is by Hook and Hastings, a premier organ builder in the United States, and given by James Forsyth as a memorial to his sister Margaret Forsyth (1846–1890). Founded in 1827, the company was operated by Elias and George Greenleaf Hook, who in 1871 took into partnership Frank Hastings, after which it was known as E. and G. G. Hook and Hastings. This is an Opus No. 1246, a one-manual stop organ built in 1885; the present Hook and Hastings organ is a 1922 Opus No. 2446, with two manuals and 29 registers.

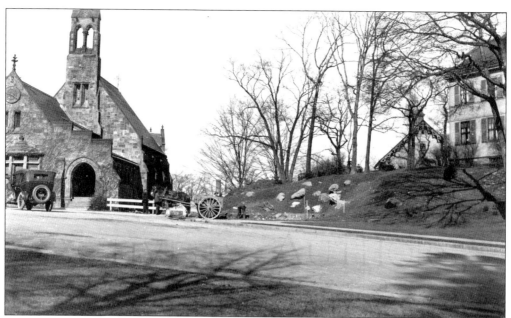

In 1922, the trustees of Forest Hills Cemetery commissioned the noted Boston architectural firm of Andrews, Jaques and Rantoul to enlarge the office. The architectural firm, with partners Robert D. Andrews, Herbert Jaques, and Augustus N. Rantoul, was both prominent and socially connected in Boston. Here workers begin clearing the lot of stones and outcroppings of Roxbury puddingstone.

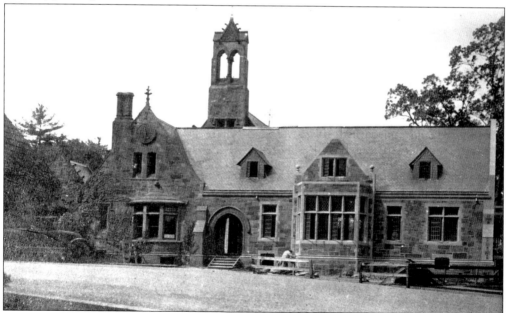

Built of Roxbury puddingstone and trimmed with limestone, the design by Andrews, Jaques and Rantoul of the enlarged office is an attractive addition to Forsyth Chapel and the original, small office. At the time of its construction, it was considered a "quiet and dignified design to harmonize with the old English ecclesiastical style of architecture. The new part is of English domestic Gothic."

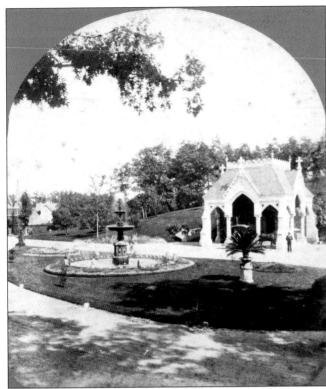

According to the *Boston Illustrated*, the receiving tomb was said in 1872 to be "the finest receiving-tomb in any cemetery in the country . . . and is built in the Gothic style of architecture in Concord granite." The portico is of white Concord granite with an oak ceiling, and its floor is paved with French encaustic tiles. On either side of the arched doorway are wall spaces for mural tablets. (Author's collection.)

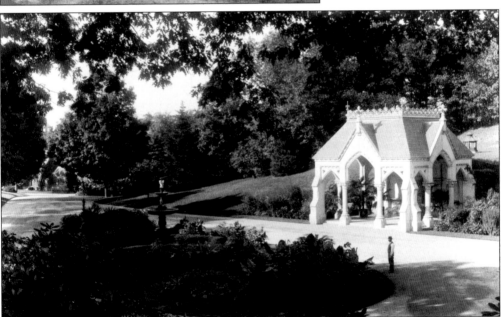

A gardener stands admiring the beautifully planted oval in front of the receiving tomb about 1895. In the Victorian period, it took a dozen or more full-time gardeners to maintain the lavish displays, lawns, and trees during the growing season. Behind the receiving tomb on the right is one of the three brick and cast-iron ventilators that allowed light and air into the subterranean interior.

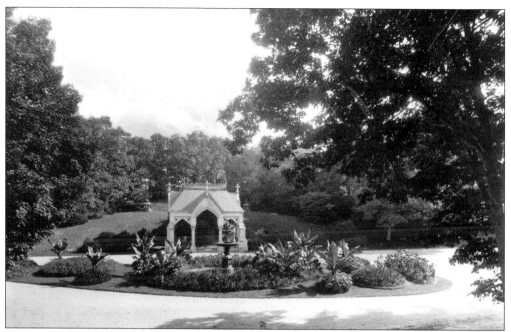

Looking at the receiving tomb from Walnut Avenue, the oval in the foreground was planted every summer with hundreds of plants cultivated or wintered over in the greenhouses behind Forsyth Chapel. Here, banana leaf trees encircle the central playing fountain and pool, and huge plantings of annuals create cushions of color and texture.

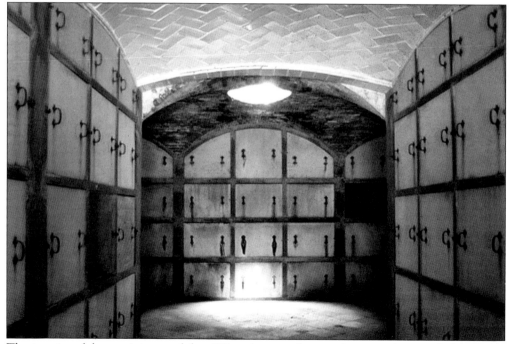

The interior of the receiving tomb has 237 underground crypts four tiers deep, each for a single coffin. These catacombs are arranged on either side of 10-foot-wide arched passages that have alternating black and white marble paving tiles and a ceiling of glazed bricks.

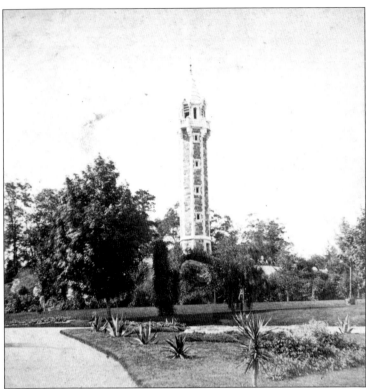

The bell tower, completed in 1876, is an eight sided 100-foot-tall observatory tower seen from Forest Hills Avenue, the curvilinear drive from Morton Street. Impressive in its design with Roxbury puddingstone set between granite blocks, it surmounts Snowflake Hill. (Author's collection.)

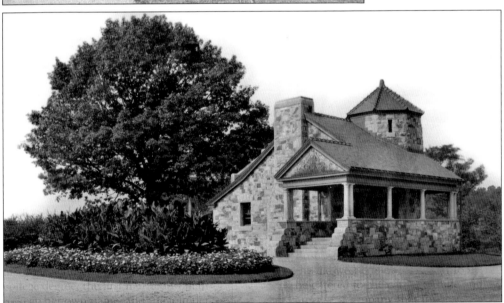

The Canterbury Street Lodge was located on the far edge of Forest Hills Cemetery at the Canterbury Street gate. It was used as a place of rest and relaxation for those looking at available lots in the Fields of Buelah and Heth. Built in 1895 of rough-hammered fieldstone, it had a porch with Doric columns and a tower capped by a six-sided red tile roof. The lodge was demolished in 1948, and on its site, a new area for burials was laid out and named Canterbury Gardens, with a large, multistoried stone birdhouse as the central focal point.

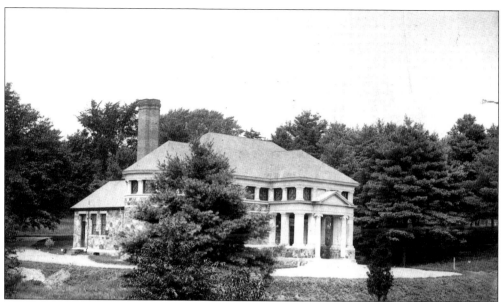

The Massachusetts Cremation Society opened a crematorium on Walk Hill Street in 1893, and it was financed by local cremation societies. The building was designed by local architect Ludvig Ipsen (1840–1920) and built of Roxbury felsite; an addition, designed by Thomas Fox and Edward Gale, was built in 1905 with a basement columbaria. The first cremation in New England took place here, in 1893, of Lucy Stone (1818–1893). In 1925, Forest Hills Cemetery acquired the crematory and since that time has almost tripled its size.

Dr. James Read Chadwick (1844–1905) was the first president of the Massachusetts Cremation Society. A graduate of Harvard College and of the Harvard Medical School, he served as president of the American Gynecological Society, the Dorchester Medical Society, and as an officer and librarian of the Boston Medical Library.

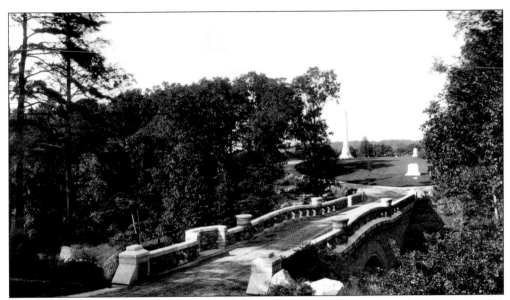

The stone bridge was designed by William Gibbons Preston (1842–1910) and built between 1891 and 1892, connecting Consecration Hill and Milton Hill, seen in the distance. The rustic bridge of rough-hewn granite and Roxbury puddingstone features intricately crafted ironwork between stone piers on both sides. The arched span of the bridge crosses over Greenwood Avenue, which connects the main gate to Hillside Avenue; Milton Hill can be seen in the distance with the Proctor family obelisk.

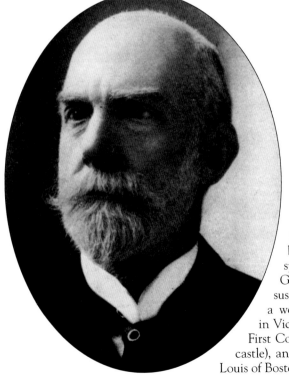

Preston was an architect whose best-known design was the bridge that spans the lagoon of the Boston Public Garden, which is the smallest true suspension bridge in the world. Preston was a well-respected and sought after architect in Victorian Boston, and he also designed the First Corps Cadet Armory (now the Park Plaza castle), and the Museum of Natural History (now Louis of Boston). (Author's collection.)

Four

ARISTOCRATS AND POLITICIANS

I like that ancient Saxon phrase, which calls
The burial ground God's acre! It is just;
it consecrates each grave within its walls,
And breaths a benison o'er the sleeping dust.
—Henry Wadsworth Longfellow

Forest Hills Cemetery has embraced people of all walks of life since its founding in 1848, but in some cases those interred here had achieved great accomplishments in their lives. Among the governors of the Commonwealth of Massachusetts interred here are Channing Cox, Alexander Rice, Curtis Guild, Eugene Foss, and William Gaston. Those who served as mayors of Boston are Benjamin Seaver, Samuel C. Cobb, Andrew Peters, Edwin Upton Curtis, and Thomas N. Hart, and mayors of Roxbury John J. Clarke, Henry Dearborn, Linus B. Comins, William Gaston, and George Lewis. Among the aristocrats of Boston, the self styled "Boston Brahmins," are Quincy Adams Shaw and his wife Pauline Agassiz Shaw, whose unfailingly generous contributions to every worthy cause made Boston a haven for social reform and education. The shipping magnates William Fletcher Weld, Robert Bennet Forbes, and Charles Brewer connected the port of Boston to all parts of the world, and brought renown and wealth to those involved. Henry A. Dearborn laid out Forest Hills and served as the first president of the horticultural society, and William Hyslop Sumner developed both East Boston and his estate on Sumner Hill in Jamaica Plan and is remembered today by the Sumner Tunnel. Doctors Joseph Warren, and his nephew John Collins Warren extolled the highest virtues of medicine. Each of these people represents the benevolent and political aspects of Boston and of their myriad accomplishments.

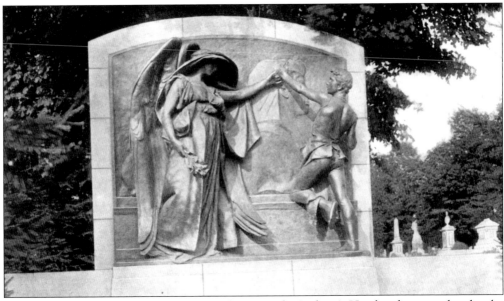

The Milmore monument is known as *Death Staying the Sculptor's Hand* and is considered to be the masterpiece of Daniel Chester French. This memorial celebrates the lives of sculptor Martin Milmore (1844–1883) and his brother Joseph (1841–1886), a talented stonecutter who taught the art of carving to Martin. The Milmore family were Irish immigrants who settled in Boston in 1851. The beautiful allegorical figure of the Angel of Death gently lays her hand on the sculptor's as a reminder that she has come to usher him away. (Courtesy of William Dillon.)

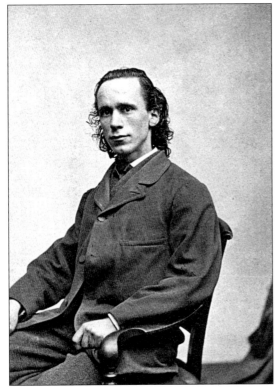

Martin Milmore was a native of Sligo, Ireland. A tall man with large dark eyes and long dark hair, he was said to be "a picturesque figure" by his sculptor friend French. Along with his brother Thomas Milmore, he was one of the most influential sculptors of the mid-19th century and was a mentor and friend to a generation of artists who continued his vision after his untimely death at the age of 39. (Courtesy of the Boston Athenaeum.)

The grave of Henry Dearborn (1783–1851) is marked by an elegant white marble urn supported by a plinth base that is inscribed, "Erected by the workmen of Forest Hills Cemetery to commemorate his many virtues." The grave is on Sweet Brier Path on a slope leading to that of his parents, which is at the crest of Mount Dearborn. (Author's collection.)

The Bangs family monument of Benjamin and Sophia Nye Bangs is on Wigelia Path and is marked by a white marble statue of *Hope* and placed on the lot in 1861. *Hope* is depicted in a sweeping gown, clutching an anchor chain to her breast, with an anchor and a copy of the Bible at her feet. Benjamin Bangs (1783–1860) was a wealthy ship owner and merchant. (Author's collection.)

The monument of William Cooper Hunneman (1769–1856) is an open Bible set on a marble altar. Hunneman produced standard pumper fire engines in Boston, and many fire engines builders purchased the pump and accessories from Hunneman and Company. From 1792 to 1883, three generations of the Hunneman family produced 750 fire engines that were shipped to all parts of the world. (Author's collection.)

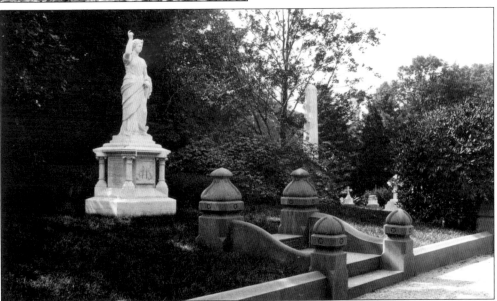

A figure of a classically inspired woman in a flowing gown leaning against an anchor surmounts the monument to Samuel G. S. Reed (1816–1883) and his wife, Caroline Webster Reed (1827–1890). The white marble base has four columns supporting it. A clipper ship in full sail and rigging are depicted on the front of the tablet. Reed was a sea captain, boat builder, and shipping merchant in Boston, and among his fleet were the ships *Shooting Star*, *Silver Star*, *Onward*, and the *Ocean Express*.

Hepzibah Clarke Swan (1757–1825) was an heiress who was among the most cosmopolitan and erudite of ladies in Federal-era Boston. Swan was said to be charismatic, not only because of her wealth but also in good measure because of her personal charm. Her estranged husband, James Swan, also sat for Gilbert Stuart, and she commissioned a portrait of her companion Gen. Henry Jackson (1747–1809), who is also buried in the lot. (Courtesy of the Museum of Fine Arts, Boston.)

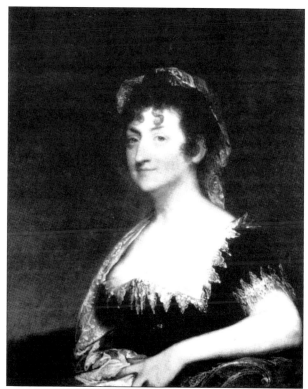

The Swan family sandstone obelisk was originally erected in a secluded area of the Swan estate on Dudley Street in Dorchester where Jackson, and later, Swan, was interred. In 1872, the obelisk and the bodies were removed by the family to Forest Hills Cemetery when the estate was sold for development.

John Pear (1793–1873) was associated with the firm of Pear and Bacall. In the 19th century, silversmiths produced a profusion of coin silver flatware and hollowware that graced elegant homes. His brother Edward Pear was joined by Thomas Mitchell (Pear and Mitchell) and later Thomas Bacall (Pear and Bacall), and for two generations, the firm provided silver to discriminating Bostonians. (Courtesy of William H. Pear II.)

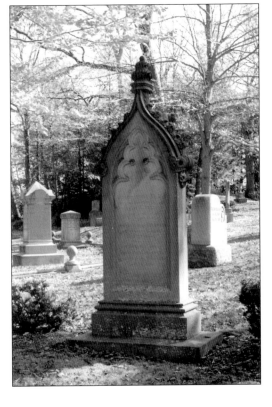

Simon Willard (1753–1848) is considered to be among the most important clockmakers in this country. He and his brothers Ephriam, Aaron, and Benjamin produced clocks that are today coveted by museums, collectors, and clock historians. His shop was in Roxbury, where he produced a wide array of clocks, including the "Roxbury tall case" and the patented banjo clocks. (Author's collection.)

Gen. William Hyslop Sumner (1780–1861) inherited Noddle's Island through his mother, and his greatest accomplishment was his effort to develop several islands in Boston Harbor. This undertaking created what is now known as East Boston. During the development, Sumner founded several companies, including the East Boston Company and the East Boston Lumber Company. The Sumner Tunnel that runs under Boston Harbor from East Boston to Boston bears his name. (Author's collection.)

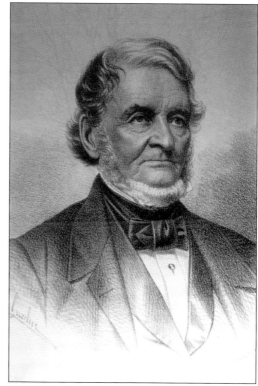

The white Carrara marble monument on the Sumner lot on Mount Warren Avenue was sculpted by Cantalamessa Papotti and was set on an outcropping of Roxbury puddingstone. Papotti's angel is part of a long artistic tradition and is a popular cemetery motif. Sumner's monument was personalized on the base with a representation of a family crest, and on the front in the circular medallion was a low-relief portrait.

The Warren family lot surmounts Mount Warren and is marked by a huge boulder of Roxbury puddingstone against which are arranged the slate headstones of various family members who were reinterred here from the Eustis Street Burying Ground in Roxbury. The Warren family continued to use this large lot well into the 20th century, with Colonial Revival slate headstones echoing those of the late 18th century.

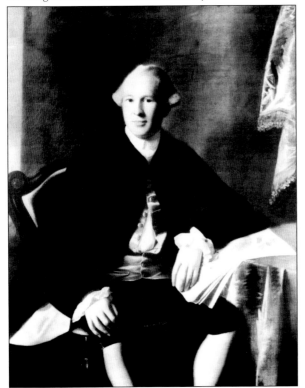

Dr. Joseph Warren (1741–1775) was a graduate of Harvard College and was a noted and well-respected physician. Author of the "Suffolk Resolves," which was a list of grievances against King George III, Warren was an ardent patriot and Son of Liberty. During the American Revolution, he was killed at the battle of Bunker Hill, and his remains were eventually moved three times before finally coming to rest in this lot, which was purchased by his nephew in 1852. (Courtesy of the Museum of Fine Arts, Boston.)

Dr. John Collins Warren (1778–1856) was a nephew of Dr. Joseph Warren and the son of Dr. John Warren, founder of the Harvard Medical School. One of the most renowned surgeons in the 19th century, in 1846, Dr. John Collins Warren performed the first public operation in which ether was used to anesthetize the patient. He was one of the founders of the Massachusetts General Hospital, where he served as the first surgeon. (Author's collection.)

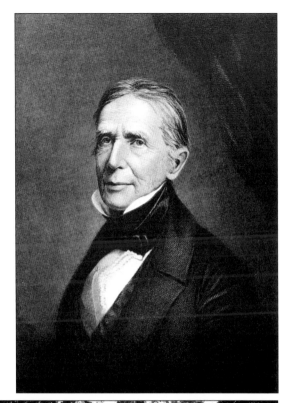

The Williams family lot is on Cherry Avenue and has a large white marble cenotaph set on a polished, granite beveled base. The monument was made in memory of John Williams (1799–1873) and his wife, Ellen Bigelow Williams (1814–1901) of Roxbury. The cast-iron fencing has been removed, and a clipped evergreen yew hedge of the same height has been planted and meticulously maintained. It encloses the family lot, which is now set with numerous individual white marble headstones.

The Weld family lot is on Linden Avenue and is marked by an octagonal white marble Gothic spire with shields along the base for each of the family members' names interred here. Among them are William Fletcher Weld's first wife, Mary Perez Bryant Weld (1804–1836), and his second wife, Isabella M. Walker Weld (1812–1906).

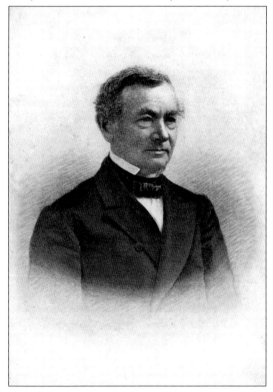

William Fletcher Weld (1800–1881) was a shipping magnate during the golden age of sail. He entered the shipping trade that had enriched his father, William Gordon Weld. By 1833, Weld made enough money to commission the *Senator*, the largest ship of her time. Weld eventually became one of the most successful merchant-ship owners in America, and he operated 51 sailing vessels. His fleet sailed under the name and symbol of the black horse flag. (Author's collection.)

Thomas Coffin Amory (1828–1864) was a Civil War Union brevet brigadier general. After graduating in 1851 from the United States Military Academy, he was made a captain in the 7th United States Regular Infantry at the start of the Civil War. He was appointed as commissary of musters serving in the department of North Carolina and was on active duty in Beaufort, North Carolina, when he died in October 1864.

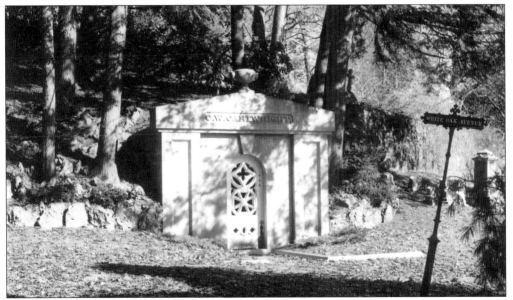

Charles Worth Cartwright (1789–1873) built one of the first mausoleums at Forest Hills in 1867 on Rock Maple Avenue on the rear slope of Dearborn Hill. Cartwright was president of the Manufacturers Insurance Company in Boston and lived on Beacon Hill and on Nantucket, where he was born and died. The mausoleum has a granite exterior with a large brownstone interior and room for 19 burials. A recent joint restoration of the mausoleum was undertaken by the family and the cemetery that has ensured its preservation. (Author's collection.)

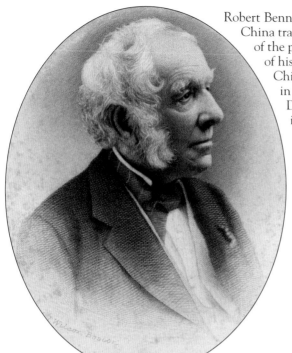

Robert Bennet Forbes (1804–1889) was a sea captain, China trade merchant, and ship owner. A member of the prominent Forbes family of Boston, much of his wealth was derived from the opium and China trade, and he played a prominent role in the outbreak of the First Opium War. Despite the ethical problems of dealing in opium, he was also well known to engage in humanitarian activities, such as commandeering the USS *Jamestown* to bring food to Irish famine sufferers in 1847. (Courtesy of the Forbes House Museum, Milton.)

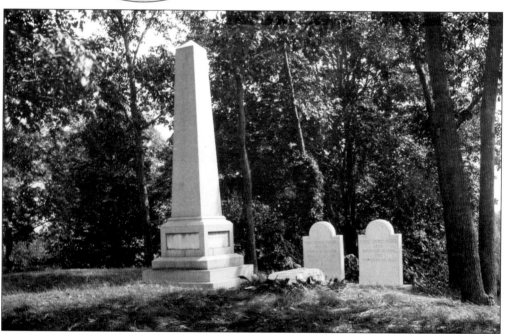

The Forbes family monument has a large granite base with white marble inset panels, and it is surmounted by a granite obelisk that is a simple but massive monument. The lot was said to be "a beautiful one in its situation, and commands a view of the hills of Milton and the intervening valley and slopes, a scene of beauty and quiet which seems to impress the beholder with a sense of the fitness of the spot for a burial place."

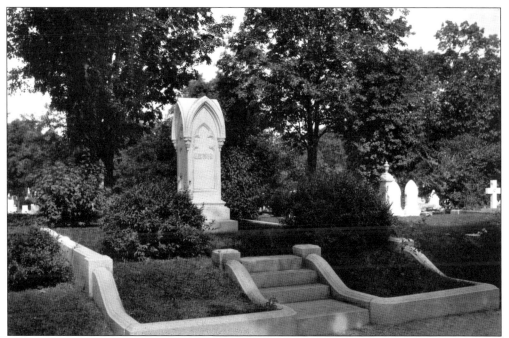

The Lewis family lot is on Cherry Avenue. Elijah Lewis (1773–1858) and Elizabeth Sumner Lewis (1791–1874) chose a white marble, four sided Gothic-inspired monument, which is also the resting place of Roxbury mayor George Lewis (1820–1887) and of his wife, Susan Minns Lewis (1827–1876).

George Lewis was the last mayor of the city of Roxbury before it was annexed to Boston in 1868. A merchant in Boston, he served as an alderman of Roxbury and treasurer of the Granite Railway Company. He also served as a trustee, commissioner, and treasurer at Forest Hills Cemetery. His white marble bust, sculpted in 1868 by Martin Milmore, is in the collection of Forest Hills Cemetery. (Photograph by Elise M. Ciregna.)

Capt. Charles Brewer (1804–1885) was founder of the Brewer Line, a packet line that regularly traveled between Boston and Hawaii. Brewer lived in Hawaii from 1836 to 1846, where his company C. Brewer and Company specialized in supplying and outfitting whaling ships and later in exporting sugar and molasses. He befriended Hawaiian king Kamehameha III, and his son Edward May Brewer served as Hawaiian consul. (Author's collection.)

Moses Williams (1790–1882) and his wife, Mary Blake Williams (1794–1853), are interred on the right of the granite-curbed lot shared on Cherry Avenue with the family of Aaron Davis Weld (1805–1889), seen on the left. He was active in the Unitarian church in Jamaica Plain and in the community. In business, he and J. D. Williams were wine and liquor merchants, with offices on State Street in Boston.

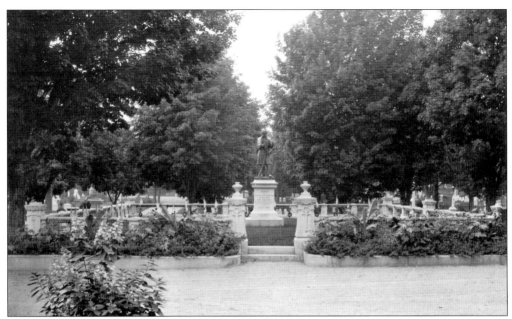

The Civil War lot was purchased by the city of Roxbury for the veterans of the war. In the center of the granite-enclosed lot is Martin Milmore's arresting *Citizen Soldier*, which was dedicated on Memorial Day in 1868. This bronze statue was glowingly described at the time as "a notable landmark in the history of American art" and launched Milmore's career as the greatest commemorator of the Union dead.

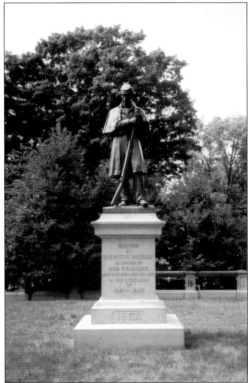

Citizen Soldier was "erected by the city of Roxbury in honor of her soldiers who died for their country in the Rebellion of 1861–1865." Sculpted by Milmore, the seven-foot bronze statue was set on a granite base and depicts a Union soldier resting on his rifle and seemingly contemplating his fellow soldiers interred in the lot. The evocative statue became the prototype of Civil War monuments erected throughout New England. (Courtesy of Helen Hannon.)

The Winslow family lot is curbed and dominated by a huge boulder, which came from Mount Kearsarge in New Hampshire. The boulder was donated by the citizens of Warner, New Hampshire, in memory of their hero John A. Winslow, who served as the captain of the USS *Kearsarge*, which sank the CSS *Alabama* during an 1864 Civil War sea battle.

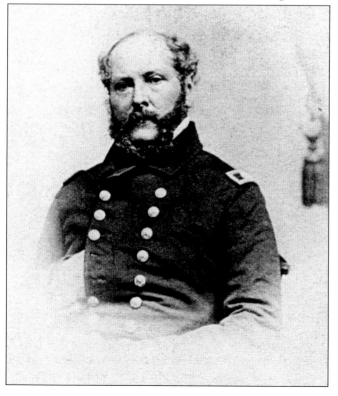

Rear Adm. John Ancrum Winslow (1811–1873) entered the navy as a midshipman in 1827 and was promoted to the rank of lieutenant in 1839 and commander in 1855. During the Mexican War, he was commended for gallantry for his activities at Tobasco. In 1864, he led troops to victory in one of the Civil War's most-notable naval actions, the battle between the USS *Kearsarge* and the CSS *Alabama*. (Courtesy Boston Athenaeum.)

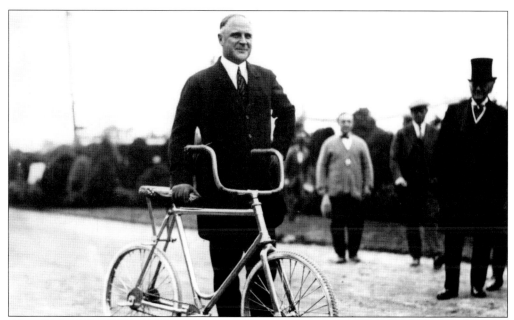

Alvin Tufts Fuller (1878–1958) was a United States representative from Massachusetts. He was elected a member of the Massachusetts House of Representatives and was a delegate to the Republican National Convention in 1916, served as lieutenant governor from 1921 to 1924, and was elected governor in 1924. After leaving office, he became chairman of the board of the Cadillac-Oldsmobile Company. (Courtesy Boston Public Library.)

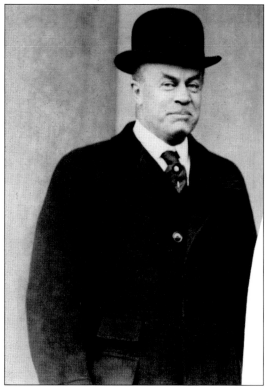

Andrew J. Peters (1872–1938) was a graduate of Harvard College and Harvard Law School and was elected to congress, where he served from 1907 to 1914. He was the assistant secretary of the treasury before he was elected mayor of Boston, serving from 1918 to 1922. During his term, the Boston Police Strike of 1919 occurred, and failing to call out the state militia, it was left to Gov. Calvin Coolidge to act, which made him a well-known figure and catapulted him to national office. (Courtesy Boston Public Library.)

The Heath monument, made of a huge granite slab, commemorates Revolutionary War hero Maj. Gen. William Heath (1737–1814). Heath was a farmer, soldier, and political leader from Roxbury, who served as a major general in the Continental army during the American Revolution. After the war, Heath served as a member of the Massachusetts Convention that ratified the United States Constitution in 1788. He served in the Massachusetts State Senate from 1791 to 1792 and as a probate court judge.

Benjamin Seaver (1795–1856) served as the 13th mayor of Boston in 1852 and 1853. He had been a member of the Boston Common Council for five years, and at the time of his election, he was in business as an auctioneer. His monument is an obelisk in the center of the lot at the corner of Cypress and Larch Avenues. Seaver was mayor when the city voted to establish a public library and when an act was passed that prohibited the burial of people within the city limits.

Channing Harris Cox (1879–1968) was a graduate of Dartmouth College and Harvard Law School and served as a member of the Massachusetts House of Representatives from 1911 to 1919. Over the next several years, he was lieutenant governor to Calvin Coolidge. Cox was noted for advancing progressive labor legislation and adjusting administrative laws to Massachusetts's changing economy. (Courtesy Boston Public Library.)

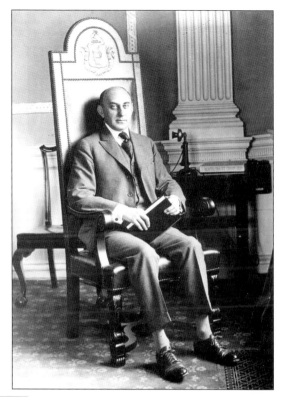

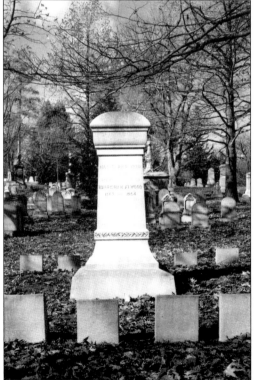

The Atwood monument commemorates Boston City architect Harrison H. Atwood (1863–1954), who served as a United States congressman. Elected to the United States House of Representatives, he also served as a member of the Massachusetts State House of Representatives. Among the schools in Boston that Atwood designed were the Nathaniel I. Bowditch, the Emily A. Fifield, and the Frank V. Thompson Schools. (Author's collection.)

Alexander Hamilton Rice (1818–1895) was a paper manufacturer and dealer with Wilkins, Carter and Company in Boston before he was elected as mayor of Boston, serving from 1856 to 1857. He served in the United States House of Representatives from 1859 to 1867, acting as chairman of the Committee on Naval Affairs from 1863 to 1865. He later served as a United States congressman during the Civil War, as well as the governor of Massachusetts from 1876 to 1878. (Author's collection.)

The Rice family monument is on Magnolia Avenue on Consecration Hill. A large, white marble memorial, it has a four-sided paneled block, and each side is surmounted by a pediment with a draped urn on top. (Author's collection.)

Quincy Adams Shaw (1825–1908) was an investor in the Calumet and Hecla Copper Mines with Henry L. Higginson. The copper mining property was prospected by Louis Agassiz and his son Alexander Emanuel Agassiz, who developed it. It proved to be an immensely important prospect. Shaw was a major art collector and donated numerous impressionistic paintings by Jean-Francois Millet to the Museum of Fine Arts in Boston. (Courtesy Museum of Fine Arts, Boston.)

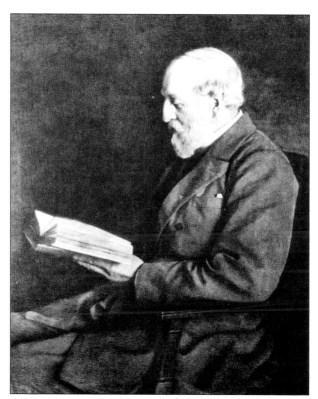

Pauline Agassiz Shaw (1841–1917) devoted her life to supporting and furthering education. In 1877, she established a kindergarten, and six years later, she was supporting 31 free kindergartens throughout Boston. She also founded day nurseries, which later became settlement houses, including the North Bennet Street Industrial School. The Sloyd Training School of Boston taught manual training and evolved into a school of craftsmanship and design. (Courtesy of the Boston Athenaeum.)

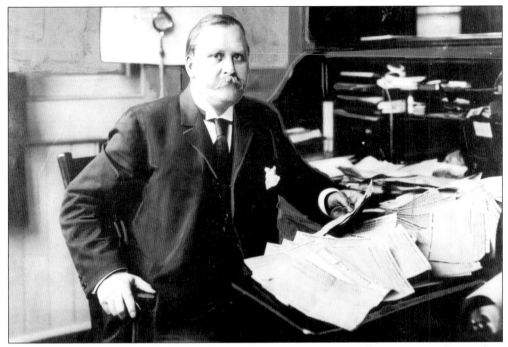

Eugene Nobel Foss (1858–1939) graduated from the University of Vermont and served as president of the Sturtevant Company. He served as governor of Massachusetts from 1911 to 1914. Afterwards, he resumed his former manufacturing pursuits, serving as president of the Becker-Brainard Milling Machine Company; the Mead, Morrison Manufacturing Company; and managed his large real estate holdings in Boston. (Courtesy of Vincent Tocco Jr.)

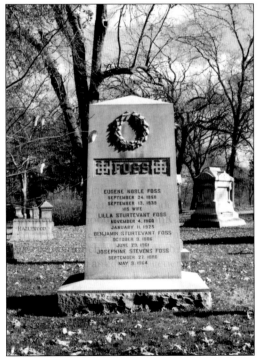

The Foss family monument is on Cedar Avenue and is a large block of dressed granite set on a rough-hammered granite base. The craved laurel wreath adds texture to the otherwise simple monument with the family name flanked by stylized art nouveau crosses. (Author's collection.)

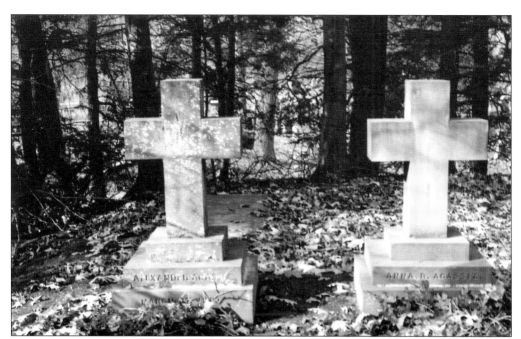

These simple brownstone crosses mark the graves of Alexander Emanuel Agassiz and his wife Anna Russell Agassiz, which are located at the crest of Mount Dearborn. The simplicity of design, material, and style belie the immense philanthropic generosity of the Agassiz family. (Author's collection.)

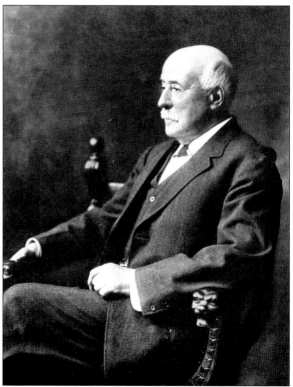

Alexander Emanuel Agassiz (1835–1910) managed the Calumet and Hecla Copper Mines in Michigan, which not only became among the largest copper mines in the world but also the most profitable, with dividends being paid annually on a consistent basis. A son of the naturist and Harvard College professor Louis Agassiz, he largely funded the Museum of Comparative Zoology at Harvard and donated many of the exhibits that he collected throughout the world. (Author's collection.)

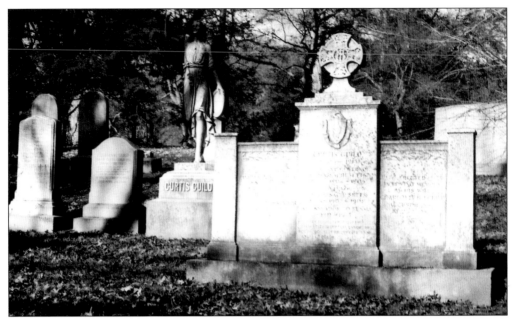

The Curtis Lot has a profusion of white marble monuments, including two angels, one of which holds an oval plaque marked Guild. The monument of Gov. Curtis Guild (1860–1915) is on the right; he was editor and publisher of the Commercial Bulletin, a newspaper founded by his father. During the Spanish American War, he was inspector general of Havana before serving as governor of Massachusetts from 1906 to 1909. He later served as special ambassador to Mexico and ambassador to Russia just prior to the Russian Revolution.

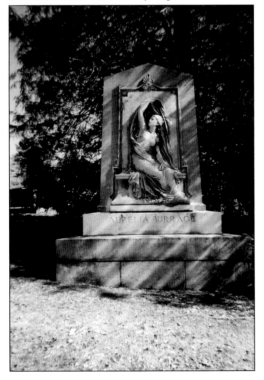

The Burrage memorial was designed in 1900 by Hugh Cairns (1861–1942) and said to represent *The Wind*, an allegorical seated female holding part of her billowing robe aloft. Albert Cameron Burrage (1859–1931) lived at 314 Commonwealth Avenue, designed in 1899 by Charles Brigham and modeled after Chenonceaux, a chateau located in the Loire Valley of France. The mansion later became the Boston Evening Clinic.

William Gaston (1820–1894) graduated from Brown University and was admitted to the Massachusetts Bar Association in 1844. A partner with Judge Francis Hilliard in the firm of Hilliard and Gaston, he served as a state representative and senator. Gaston served as mayor of the city of Roxbury, mayor of the city of Boston, and governor of Massachusetts. It was he who drew up the legislation that incorporated Forest Hills Cemetery and served as wise counsel to the cemetery trustees for many years. (Author's collection.)

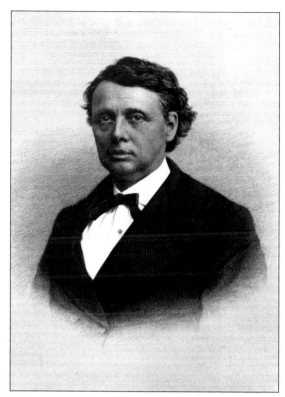

The Gaston family lot has a tall, white marble monument with a profusion of decorations, including a neoclassical wreath, garland, and draped urn. In addition to the late governor, William A. Gaston (1859–1927) is interred here. He was partner in a law firm, which was then known as Gaston, Snow and Saltonstall. He was an overseer of Harvard College and president of the Boston Elevated Railway.

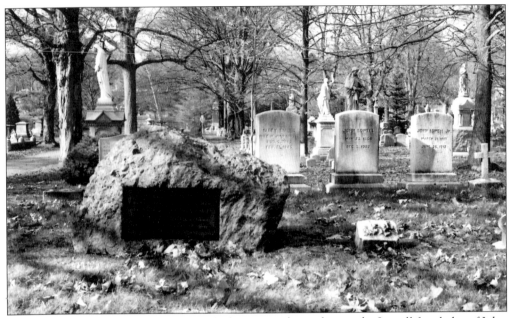

A boulder of Roxbury puddingstone and a bronze marker indicates the Lowell family lot of John Lowell (1824–1897) and his wife, Mary Buckminster Lowell. He was the son of John Amory and Susan Cabot Lowell and was born at Bromley, the Lowell family seat in Roxbury. Educated at Harvard College and the Harvard Law School, he served as judge of the District Court of the United States. (Author's collection.)

Judge John Lowell (1743–1802) was a member of the Continental Congress and was called "the very mirror of benevolence." In 1783, Lowell was one of the founding directors of the First National Bank of Boston. The old judge and members of the Lowell family were removed from the family tomb in the Boston Common Burial Ground in 1895 to Forest Hills to allow for the construction of the Boylston Street subway. (Author's collection.)

Five

ACTIVISTS, AUTHORS, AND EDUCATORS

Things past belong to Memory alone;
Things Future are the property of Hope.

—John Howe

Many of those interred at Forest Hills Cemetery have made significant contributions to American society as activists, authors and educators. Karl Heinzen was an activist both in Germany as well as Boston, and his forthright and bold views on activism and social reform were shared by people such as Mary Hunt, Lucy Stone, William Lloyd Garrison, and Alice Stone Blackwell, whose views on temperance, abolition, and women's rights brought reknown, respect, and attention to them in the Victorian period. Authors such as Edward Everett Hale, Charles Follen Adams, and James Freeman Clarke raised the intellectual aspects of Bostonians while poets Ann Sexton, Eugene O'Neill, and E. E. Cummings delighted readers with their poems, sonnets, and plays that entertained as well as made readers expand how they think. Educators William Coe Collar and Alonzo Ames Miner instilled a sense of thought in the generation after the Civil War and broadened the once placid viewpoint of "cold roast Boston." Medical pioneers Marie Zakrzewska, Susan Dimock, and Elizabeth Abbott Carlton brought care and comfort to the ill of Boston and are still lovingly remembered a century after their deaths.

Looking up Sweet Brier Path along the edge of Mount Dearborn, there are the graves of four notable personages at Forest Hills Cemetery—Karl Heinzen, Louis Prang, Dr. Marie Elizabeth Zakrzewska, and Dr. Susan Dimock. These four neighbors were to represent a social activist, a lithographer, a founder of a hospital, and an early female surgeon. In a microcosm, they represent the diversity of Victorian Boston. (Author's collection.)

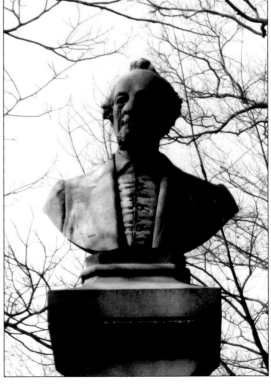

Heinzen (1809–1880) was a prominent writer and revolutionary who came to Boston in the 1850s. He published the *Pioneer*, which was an independent, intellectual, German-language journal that expounded on his views "on topics as diverse as women's rights, abolition, diet reform, music." A bronze bust of Heinzen was sculpted by A. Robert Kraus. (Photograph by Elise M. Ciregna.)

Susan Dimock (1847–1875) was among the first female surgeons in the United States. In 1866, she entered the New England Hospital for Women and Children, where she studied by close observation in the wards and dispensary and then pursued medical study in Zurich, Switzerland, where she graduated with high honors in 1871. Dimock worked as a surgeon, developing a private practice in obstetrics and gynecology and performing a number of important surgical operations.

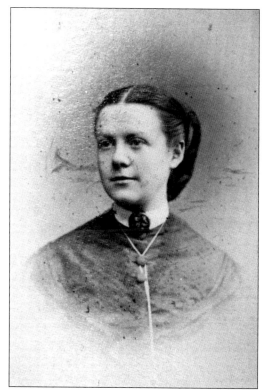

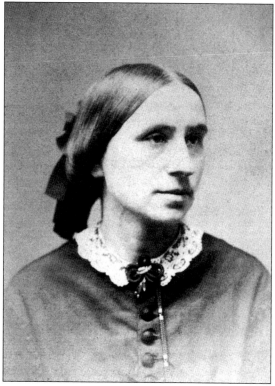

Marie Zakrzewska (1829–1902) was a native of Poland, was educated at the Cleveland Western Reserve Medical College, and taught obstetrics at the New England Female Medical College in Boston. "Dr. Zak," as she was known, was the founder of the New England Hospital for Women and Children in 1862. Its mission was to provide specialized medical care for women and children. The first professional nursing program in this country was launched in this hospital. (Courtesy of the Schlesinger Library.)

Dr. Elizabeth Abbott Carleton (1851–1925) was the founder of the Home for Aged Couples, the first of its kind in New England. Located at the corner of Seaver Street and Walnut Avenue in Roxbury, it merged in the late 20th century with the Willard Home and moved to Bedford, where is has since been known as Carleton Willard Village. (Author's collection.)

Lucy Stone (1818–1893) was a leader of the national women's rights movement and was referred to as "the morning star of the woman's rights movement." She was an organizer of the Massachusetts Anti-Slavery Society, the first Massachusetts woman to receive a college degree, the first married woman to keep her own name, and the founder and editor of the *Women's Journal*. She was the first person to be cremated in New England at the Massachusetts Cremation Society. (Courtesy of the Archives and Special Collections, University of Massachusetts.)

Mary Hunt (1830–1906) was a leader in the campaign for temperance education in the Boston Public School System and eventually throughout the United States. While working at the Patapsco Female Seminary, she began to study the physiological effects of alcohol. Through the Woman's Christian Temperance Union, Hunt advocated for thorough textbook study of scientific temperance in the public schools, which eventually lead to the 18th Amendment and a period of prohibition in the United States. (Author's collection.)

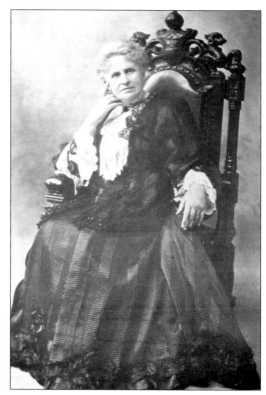

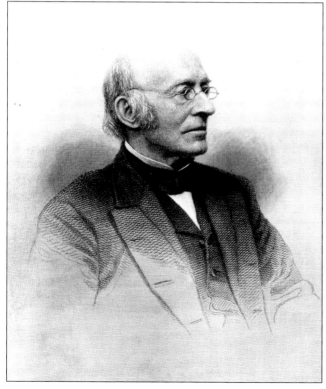

William Lloyd Garrison (1805–1879) was among the most vociferous of the abolitionists in Boston in the three decades leading up to the Civil War. Garrison was the editor of the *Liberator*, a weekly newspaper that from 1831 to 1865 was the voice piece of those advocating for the abolition of slavery in the Southern states. Garrison founded the New England Anti-Slavery Society and made a name for himself as one of the most articulate and most radical opponents of slavery.

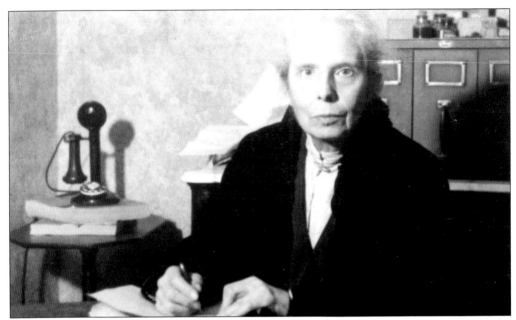

Alice Stone Blackwell (1857–1950) was a noted reformer and woman's rights advocate, and she followed Lucy Stone, her mother, as editor of the *Woman's Journal*, which, since 1870, had been the voice piece of the American Women's Suffrage Association. Her biography of her mother was acclaimed, and she was an ardent supporter of Armenian causes and of the Friends of Russian Freedom, translating poetry of oppressed peoples into English. (Author's collection.)

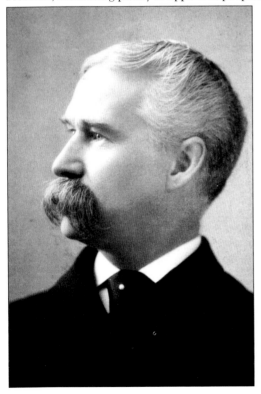

Charles Follen Adams (1842–1918) was a dry goods dealer in Boston as well as a popular dialect writer, composing stories and poems in the heavily accented English spoken by German immigrants. He contributed to the *Oliver Optic's Magazine*, *Scribner's Monthly*, and his books *Leedle Yawcob Strauss* and *Dialect Ballads* were immensely popular. His jovial characters Leedle Yawcob Strauss and Dot Leedle Louisa were modeled on his children Charles Mills Adams and Ella Paige Adams Sawyer. (Author's collection.)

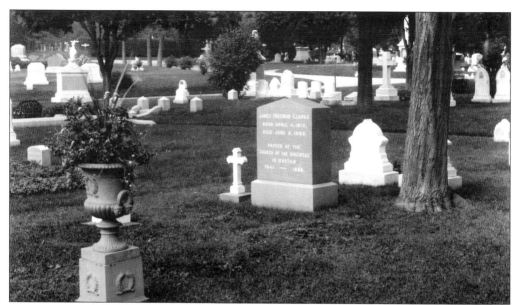

James Freeman Clarke (1810–1888) was the charismatic and well-respected pastor of the Church of the Disciples on West Brookline Street in Boston's South End. His writing is sometimes perceived as controversial, declaring that the business of the church is eirenic and not polemic. His book *Orthodoxy: Its Truths and Errors* has been read by more members of orthodox churches than by Unitarians. In the great moral questions of his time, Clarke was seen as an advocate of human rights.

Ann Harvey Sexton (1928–1974) was a poet whose words were ones of self-exploration and intense soul searching; writing in some ways must have eased the anguish and turmoil of her private life. Recipient of a Pulitzer Prize in 1967 for *Live or Die*, a National Book award, and a Guggenheim award, her books included *To Bedlam and Part Way Back*, *Live or Die*, and *The Death Notebooks*, which all seem to outline her chronic depression and espouse her preoccupation of death.

Eugene Gladstone O'Neill (1888–1953) was an American playwright and Nobel laureate in literature. His numerous plays are among the first to introduce into American drama the techniques of realism associated with playwrights Aton Chekov, Henrik Ibsen, and August Strindberg. His plays were among the first to include speeches in the American vernacular and were embraced with alacrity by the public. His plays often involved characters who inhabit the fringes of society, engaging in depraved behavior, where they struggle to maintain their hopes and aspirations but ultimately slide into disillusionment and despair.

Edward Estlin Cummings, more popularly known as E. E. Cummings (1894–1962), was an important novelist and poet that not only captivated 20th-century readers with his writing and poetry, but he also created a distinctive lower-case spelling of his name. A graduate of Harvard University, Cummings was an American poet, painter, essayist, author, and playwright. His body of work encompasses approximately 2,900 poems, an autobiographical novel, four plays, and several essays, as well as numerous drawings and paintings. He is remembered as a preeminent voice of the poetry of the 20th century.

Susanna Haswell Rowson (1762–1824) was a well-known educator who kept a young ladies' academy in early-19th-century Boston. She was author of the best-selling novel *Charlotte Temple*, published in 1791, which proved a popular read for salaciously minded Bostonians. In addition to her writing, Rowson was a popular lecturer, songwriter, and educator whose young ladies academy was in Boston's South End.

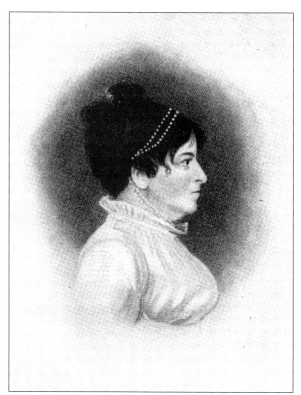

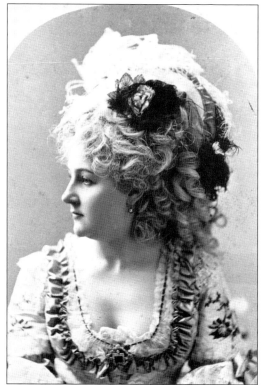

Fanny Lily Gypsy Davenport (1850–1898) was a well-known actress in the late 19th century. Davenport was successful in a wide spectrum of roles that went from Shakespeare to French melodrama; she achieved fame by obtaining the American rights to the dramatist Victorien Sardou's highly emotional plays. This photograph from about 1880 depicts her as the spendthrift Lady Teazle in the comedy of manners *School for Scandal*. (Author's collection.)

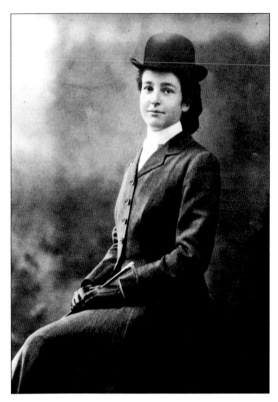

Amelia Peabody (1890–1984) was a noted sculptor, having studied with Bela Pratt and Edmund Tarbell. She was the daughter of Frank Everett Peabody, who was a partner of Kidder Peabody and Company, and she "created a life-long reputation in her own right, not only for her artistry, but also for her philanthropy, patronage of the arts, civic leadership, love of animals, and equestrian pursuits." The Peabody lot, set in a dense grove of trees, is marked by a huge Roxbury puddingstone boulder.

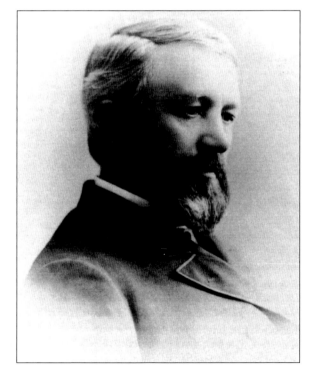

William Coe Collar (1833–1916) was headmaster of the Roxbury Latin School, which was founded in 1645 by Rev. John Eliot and is the oldest continuous preparatory school in the United States. Collar was credited as being the second founder of the Roxbury Latin School, training three generations of young men who were fitted for college under his tutelage.

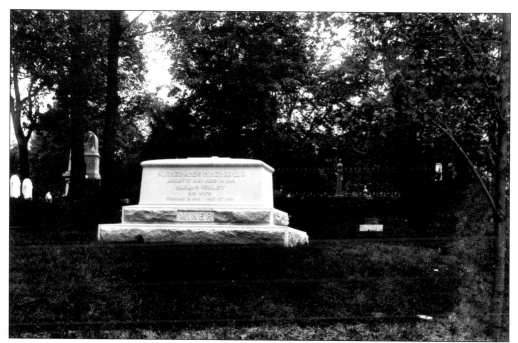

The Miner monument is of a simple granite design set on a double-tiered base of rough-hammered granite, it creates a simple but imposing site. On the upper left is the Sumner family monument.

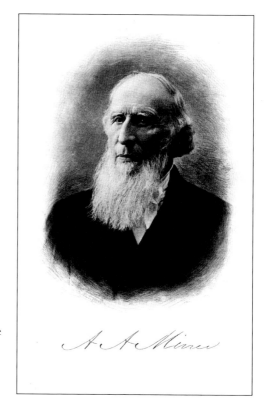

Alonzo Ames Miner, DD, LLC (1814–1895) was pastor of the Second Universalist Church in Boston's South End, served as a member of the Massachusetts Board of Education, and was chairman of the board of visitors of the state normal art school. He became the second president of Tufts University in Medford, serving from 1862 to 1875. One of the founders of Tufts, he rescued the college from near bankruptcy and instituted many new educational programs as president. (Author's collection.)

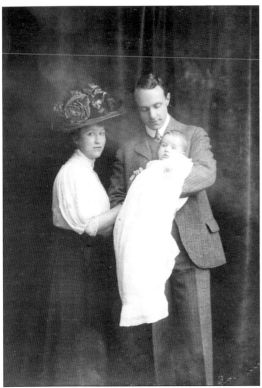

The Thaw family posed for this photograph in 1908. On the left is Jane Olmstead Thaw (1880–1958), and holding their young son Teddy is Edward Thaw of the Pittsburgh Thaws. His sister was Alice, Countess of Yarmouth, later the wife of Geoffrey W. Whitney, and his brother was Harry Kendall Thaw. (Courtesy of Jane Whitney Marshall.)

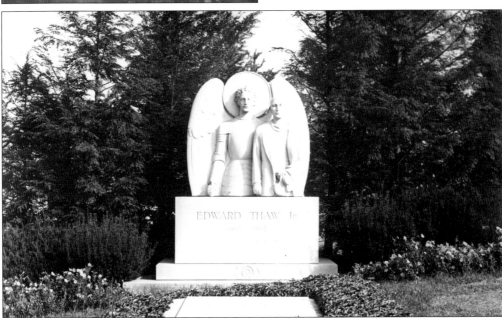

The Thaw memorial was sculpted by Gerome Brush (1888–1954), one of the foremost American memorial sculptors and son of the noted artist George de Forest Brush. Although Gerome Brush was trained to be a painter, his father also tutored him in sculpture. The white marble monument shows *Michael the Archangel* with Edward Thaw Jr. (1908–1934) holding his helmet and goggles. He was killed in an airplane accident over Nevada.

The Allen lot has a large granite monument surmounted by a draped allegorical figure. On the left is a remarkably well preserved white marble statue of Gracie Sherwood Allen, which has been under glass for well over a century. Allen (1876–1880) died of whooping cough and was immortalized by sculptor Sydney H. Morse (1832–1903), who depicted the young girl in a buttoned dress, boots, and bow-tied hair. (Author's collection.)

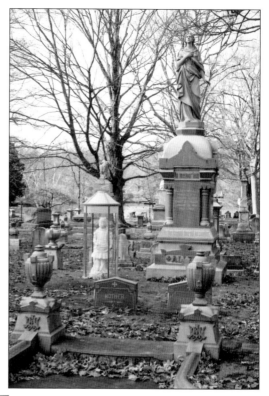

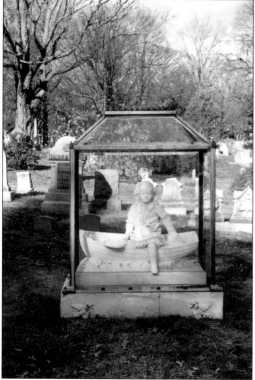

Boy in the Boat is one of the most beloved memorials at Forest Hills. In 1886, while in a small boat near the shore of a pond, Louis Mieusset (1881–1886) noticed his pet rabbit running along the bank. He reached for his pet, lost his balance, fell out of the boat, and drowned. It is this final moment of life that Louise Hellium Mieusset chose to commemorate in her son's last resting place in Forest Hills Cemetery. The marble monument was enclosed in a glass and bronze enclosure that has preserved it. (Author's collection.)

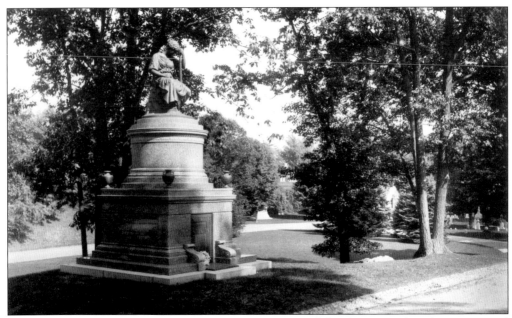

The Randidge monument commemorates George L. Randidge (1820–1890) and was executed in 1891 by sculptor Adolph Robert Kraus, with the enormous plinth base designed by the noted Boston architects Carl Fehmer and Samuel F. Page. The bronze seated figure of *Grief* in classical robes leans in sorrow on an inverted torch. Bronze funerary urns decorate the four corners of the base.

Kraus was the sculptor of *Grief*. He was a well-known sculptor who also did the Jacob Wirth memorial *Fame* and the bust of Karl Heinzen that surmounts his monument. (Author's collection.)

Edward Everett Hale (1822–1909) was pastor of the South Congregational Church in Boston's South End from 1856 to 1899. However, he is well known as the author of *A Man Without a Country*, which was published in 1863, and did much to strengthen the Union cause during the Civil War. Hale, in retirement, served as chaplain of the United States Senate. He once said, "I am only one, but I am one. I cannot do everything, but I can do something. What I can do, I should do and, with the help of God, I will do."

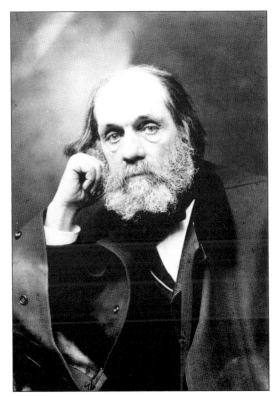

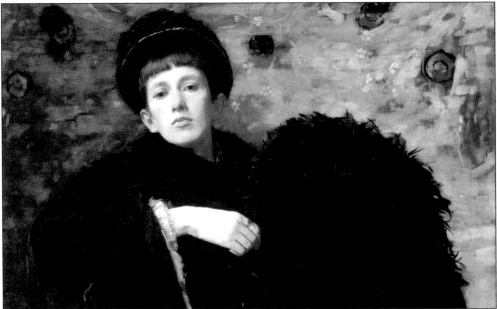

Boston painter Ellen Day Hale (1855–1940), her brother noted artist Philip Leslie Hale, and his wife Lillian Wescott Hale are all interred in the Hale lot. Ellen Day Hale studied with William Rimmer and William Morris Hunt in Boston and attended the Academie Julian. Hale was accomplished in many of the arts, writing a number of articles and books, including the *History of Art*, published in 1888. (Courtesy Museum of Fine Arts, Boston.)

John Andrews Fox (1836–1920) is considered to be the father of stick-style architecture in the United States. He was initially associated with the civil engineering firm of Garbett and Wood and later had an independent architectural practice in Boston for 50 years. He was active in the Boston Society of Architects and the Boston chapter of the American Institute of Architects, which he helped found in 1870. (Courtesy of Walter S. Fox Jr.)

Marshall Pinckney Wilder (1798–1886) was a horticulturist, and his estate in Dorchester was known as Hawthorne Grove. Wilder served as the third president of the Massachusetts Horticultural Society from 1840 to 1847, as well as president of the American Pomological Society, which has awarded the Wilder medal since 1873. Wilder hybridized camellias, and among them are the award-winning *Camellias Wilderi, Mrs. Abby Wilder, Mrs. Julia Wilder,* and the *Jenny Wilder.* In 1839, the entire collection of greenhouse and garden plants from his estate went to the Boston Public Garden. (Author's collection.)

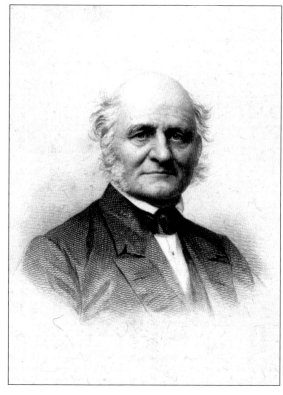

The Upham family monument was erected by Charles A. Upham (1822–1894), the son of Amos Upham (1788–1879), who in 1804 opened a corner grocery store at what subsequently was to become known as Upham's Corner in Dorchester. Three generations of the Upham family provided staple and fancy goods from the same corner for almost a century. (Author's collection.)

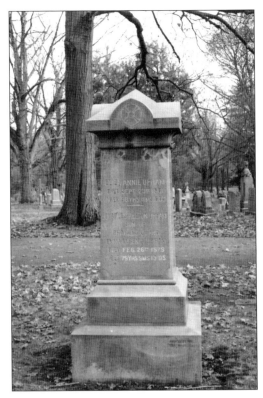

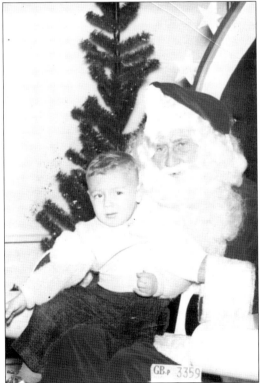

C. Kelton Upham (1899–1979) portrayed Santa Claus at Filene's department store in the two decades following World War II after an illustrious career as an English teacher in the Everett Public Schools. Here in 1960, the author sits on Santa Upham's lap, replete with a red velvet throne and an artificial Christmas tree. (Author's collection.)

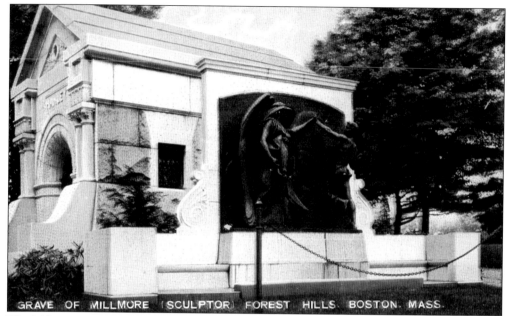

GRAVE OF MILLMORE (SCULPTOR) FOREST HILLS. BOSTON. MASS.

The Milmore monument, *Death Staying the Hand of the Sculptor*, was originally at the triangular lot bounded by Poplar Avenue (left) and Cypruss Avenue and was beside the Hanley family mausoleum. The monument was moved in 1943 at the request of the Milmore family to its present site near the gateway on Forest Hills Avenue, and the lot was landscaped by Arthur Ashael Shurcliff and Sidney Nichols Shurcliff. (Author's collection.)

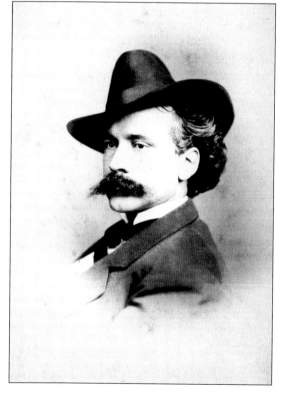

Martin Milmore (1844–1883) was a native of Sligo, Ireland. A tall man with large, dark eyes and unruly long dark hair, he was said to be "a picturesque figure" by his sculptor friend Daniel Chester French. He cut a dashing figure in his signature black broad-brimmed hat and cloak and his "appearance was striking, and he knew it." Milmore's soul-inspiring statues and monuments to the Union dead served as models for a generation of sculptors. (Courtesy of the Boston Public Library.)

Six

Philanthropists, Financiers, and Manufacturers

Who knows but in their sleep may rise
Such light as never Heaven let slip through
To lighten Earth from Paradise?

—Algernon C. Swinburne

The large number of philanthropists, financiers and manufacturers who are interred at Forest Hills Cemetery is remarkable, but the fact that many left lasting legacies to Bostonians through bequests that are still enjoyed decades after their deaths ensures that their benevolence will long be remembered. William A. Paine and Clarence Walker Barron were to revolutionize Boston's financial center through Paine Webber and Company and *Barron's Weekly*. Manufacturers and businessmen such as George Robert White, the Forsyth brothers, Andrew Carney, and Eben Jordan Jr. left lasting legacies such as the White Fund, Forsyth Dental Clinic, Carney Hospital, and Jordan Hall. S. S. Pierce, Oliver Ditson, A. A. Pope, and Louis Prang are remembered for gourmet groceries, sheet music, the Columbia bicycle, and chromolithographs. Many of the manufacturers such as Bernard Jenny, John Reece, John Souther, and Jacob Wirth ensured that gasoline, buttonholes, steam shovels, and bratwurst and beer would not only make life easier, but far more enjoyable.

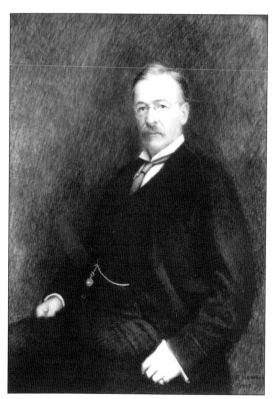

William Alfred Paine (1855–1929) was a businessman who cofounded the stock brokerage firm of Paine Webber. In 1880, with a loan from his minister father, he partnered with Wallace G. Webber to create the brokerage firm Paine, Webber and Company, becoming members of both the Boston and New York Stock Exchanges. Paine also invested in the Copper Range Consolidated Company, a major copper mining venture in Michigan, of which he served as president. (Courtesy of Susan W. Paine.)

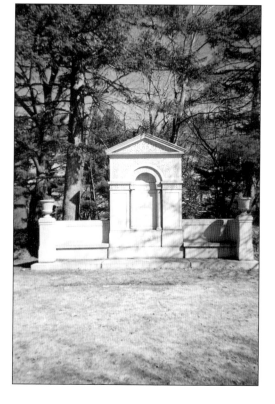

The Paine monument was designed by Louis C. Tiffany studios. A large limestone memorial with a center pediment section flanked by high-backed seats in the form of an exedra, it had urns surmounting the end plinths. The Celtic-inspired tracery on the top portion of the monument and the pediment add lightness to the design with a recessed arched opening with flanking Doric columns. (Author's collection.)

Louis Prang (1824–1909) was an American printer, lithographer, and publisher. In 1856, Prang produced lithographs and began work in colored printing of advertising. The firm became extraordinarily successful and also became well known for war maps, printed during the Civil War and distributed by newspapers. At Christmas in 1873, Prang began creating colorful greeting cards for the popular market and began selling the Christmas card in America. Prang is often called the "father of the American Christmas card." (Author's collection.)

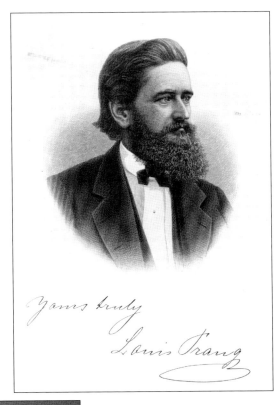

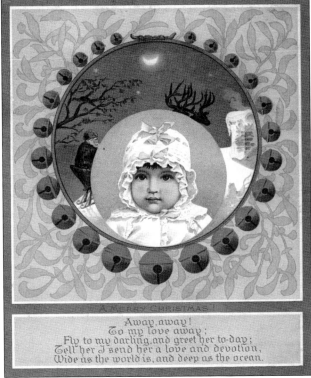

A merry Christmas card from the 1880s that was printed by Prang showed the quintessential Victorian child in a sleigh bell–decorated circle with Santa Claus and reindeer on a snowcapped roof. "Away, away! To my love away; Fly to my darling, and greet her today; Tell her I send her a love and devotion, Wide as the world is, and deep as the ocean." Prang's colorful and artistic greeting cards epitomized the Victorian era's sentiments. (Author's collection.)

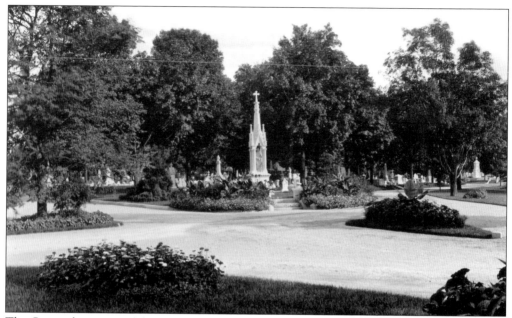

The Carney lot is one of the most prominent sites in the cemetery, overlooking Lake Hibiscus. The Carney memorial is an elaborate confection of white marble Gothic ornamentation with an angel set under a baldicchino, a four-sided cap, and a center pinnacle surmounted by a cross. Andrew Carney was initially buried in the chapel at the Carney Hospital in South Boston but was moved and reinterred at Forest Hills by his wife, Pamelia Reggio Carney (1793–1875).

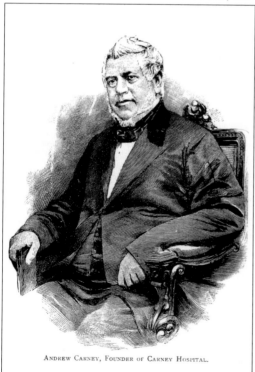

ANDREW CARNEY, FOUNDER OF CARNEY HOSPITAL.

Andrew Carney (1794–1864) was called "one of God's noblemen," as he endowed a hospital that still bears his name in Dorchester. He joined with Jacob Sleeper in the firm of Carney and Sleeper, manufacturers of men's ready-made clothing. His generosity helped to establish Boston College and the Immaculate Conception Church in Boston's South End. The Carney Hospital was founded in 1863 to serve the needs of all "where the sick without distinction of creed, color or nation shall be received and cared for." (Courtesy of the Archdiocese of Boston.)

Pietro Paulo Caproni (1862–1928) was founder and co-owner with his brother Emilio Caproni of P. P. Caproni and Brother, manufacturers of plaster reproductions of classical and contemporary statues. Symphony Hall in Boston has 16 life-sized mythical and real-life statues in niches by Pietro Paulo Caproni. The memorial to him was designed by Ralph Adams Cram (1863–1942). The monument is flanked by statues of the sleeping and awakening lions, which are based on Antonio Canova's design for the tomb of Pope Clement XIII in Rome. (Author's collection.)

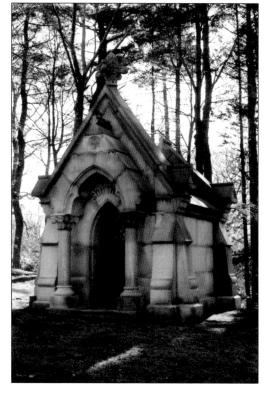

The Souther family mausoleum is a granite Gothic Revival structure that is set among maple and cypress trees. John Souther (1816–1911) was an engineer from South Boston who invented the Souther Steam Shovel, which made the filling of Boston's Back Bay possible. Souther was president of the Globe Locomotive Works in Boston and invented dredging machines, which were used in the Cuban sugar trade, but the steam shovel made him a wealthy man.

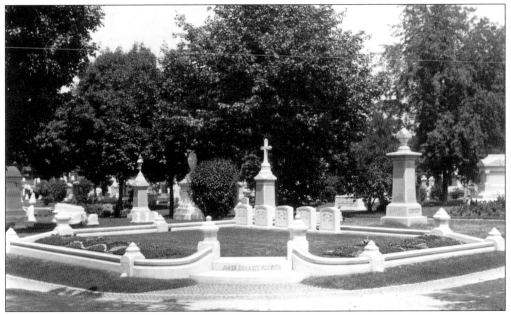

The Forsyth lot has small markers for family members, including James Bennett Forsyth (1850–1909), who, with his brothers George, Thomas, and John Hamilton Forsyth, founded the Boston Belting Company, which specialized in vulcanized rubber. Margaret Forsyth (1846–1890) is also buried in the lot, and it was in her memory that Forsyth Chapel was built and dedicated. The Forsyth family endowed the Forsyth Dental Clinic on the Fenway in Boston.

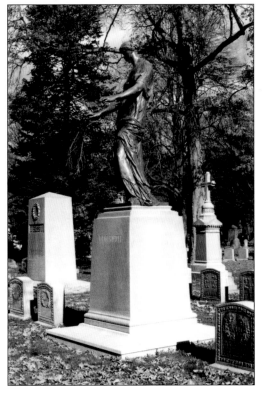

The Forsyth memorial was cast in bronze in 1911 by sculptor Lee Lawrie (1877–1963) and placed in the center of the Forsyth lot. The female statue has outstretched hands, and her stance creates an elegance and fluidity of motion, with the rippling of her gown captured in bronze. Laurie became internationally famous when he designed *Atlas*, which was placed at Rockefeller Center in Manhattan. (Author's collection.)

The Reece family monument was sculpted by William Ordway Partridge (1861–1930) in his studio on Milton Hill. This monument is similar to one he modeled of a heroic, seated statue of William Shakespeare that was erected in Chicago. The Reece memorial is in the form of an exedra, an elliptical bench with a high back decorated with a bronze wreath and a seated bronze sculpture of John Reece.

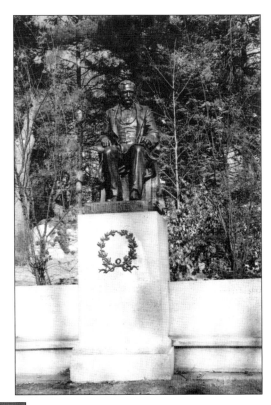

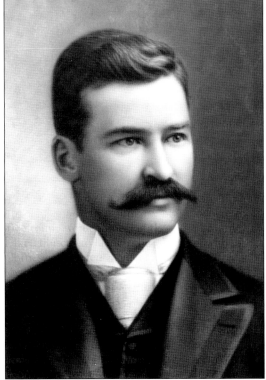

John Reece (1854–1896) was the president of the Reece Buttonhole Machine Company in Boston. In 1881, he invented and received a patent for a Button Hole Sewing Machine that revolutionized hand sewing with a machine, which increased production and standardized the size of buttonholes. Reece lost his life when he was killed trying to save an employee in his factory, who was in danger of being crushed by a moving elevator. (Courtesy of the Boston Public Library.)

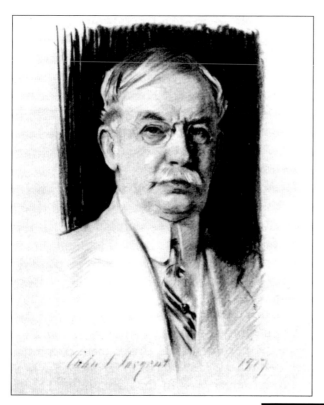

George Robert White (1847–1922) was one of Boston's greatest benefactors. President of the Potter Drug and Chemical Corporation, White's success was ensured by Cuticura Soap, which literally translated as "skin care," and embodied some of the medicinal properties of an ointment that cured rashes. He created the George Robert White Fund "to be used for creating works of public utility and beauty, for the use and enjoyment of the inhabitants of the City of Boston."

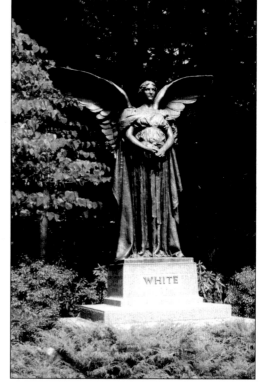

The Angel of Peace was sculpted by Daniel Chester French and installed in 1905 on the White lot on Magnolia Avenue. The angel stands majestically with clasped hands in a classically draped gown and robust, outstretched wings. The landscaping was designed by the Olmstead Brothers firm to enhance the sculpture. Another angel memorial for George Robert White, also sculpted by French, was erected in 1924 in the Boston Public Garden, which depicted an angel casting bread upon the water. (Author's collection.)

The simplicity of the individual marble headstones on the Evans lot belies the generosity of Robert and Maria Antoinette Hunt Evans. Robert Dawson Evans (1843–1909) was president of the United States Rubber Company and the United States Mining Company. Their art collection was donated to the Museum of Fine Arts in Boston and is displayed in a wing that bears their name, which was designed by Guy Lowell and built in 1915. Maria endowed the Evans Memorial Department of Clinical Research at Boston University and the Harvard Dental School. (Author's collection.)

Thomas Norton Hart (1829–1927) was a noted businessman and mayor of Boston from 1889 to 1890 and 1900 to 1902. Hart founded Hart, Taylor and Company, which was one of the largest cap and hat manufacturers in New England. He served as a Boston alderman, a member of the Common Council, and as the mayor. It was said "while mayor, he attended strictly to his duty, seeing that the streets were swept, the city finances were put into systematic shape."

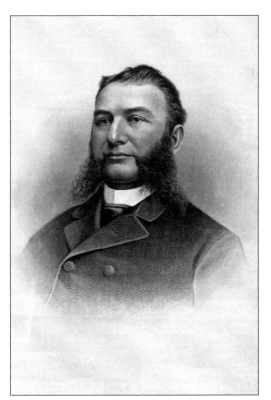

Abraham Shuman (1838–1918) was a merchant and philanthropist in Boston. His department store was known as A. Shuman and Company, the largest youth's and men's retail garment house in New England. It was located for six decades on Shuman's Corner at Washington and Summer Streets. Shuman served as president of the trustees of Boston City Hospital in the South End and of numerous banks in Boston. (Author's collection.)

The Schouler monument is on Camelia Path and was erected to the memory of Gen. William Schouler (1814–1872). Schouler served as adjutant general during the Civil War, was founder of the *Lowell Courier* and editor of the *Boston Daily Atlas*, and was the author of the *History of Massachusetts in the Civil War*. There once was a cameo portrait of him encircled by a wreath on the front. (Author's collection.)

The Armstrong family lot has a large limestone monument in the center with a robust Celtic-inspired floral carving that frames the center tablets. The lot has small individual headstones for family members that flank the central monument. (Author's collection.)

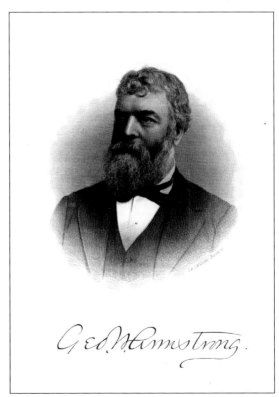

George Washington Armstrong (1836–1901) was the founder of the Armstrong Transfer Company, a leading transferring company of freight and baggage between railroads throughout New England. Boston's port, the numerous railroad depots, which made freight transfer a major business concern, and Armstrong were among the more successful in this field. (Author's collection.)

Thomas Groom (1811–1888) was the founder of Groom's Stationary Store, one of the most respected and longest-operating companies in the city. The stationary, paper, and office supply company was a Boston institution that was both popular as well as successful. In 1851, Groom was referred to in *The Rich Men of Massachusetts* as a "man highly respected for his honorable and fair dealing." (Author's collection.)

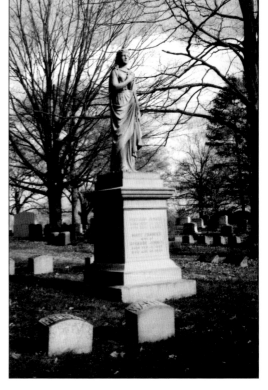

Bernard Jenney (1827–1918) began the Jenney Manufacturing Company in 1861; the family had founded Jenney Oil Company in 1812. Jenney initially manufactured burning fluids, a mixture of camphene and alcohol, before he dealt exclusively in the production and distribution of petroleum. It was said that by the early 20th century, the Jenney Oil Company works in South Boston had a capacity of 500 barrels of oil a day. (Author's collection.)

Benjamin Franklin Sturtevant (1833–1890) was an inventor and industrialist who filed more than 60 U.S. patents that related to fans. He revolutionized manufacturing worldwide and played a special role in the advancement of the shoe-making industry in the mid-19th century. Sturtevant built the first commercially successful blower, and the factory at the time was the largest fan-manufacturing plant in the world. (Author's collection.)

Joseph Samson Waterman (1830–1893) founded an undertaking firm in 1832. His sons George H. and Frank S. Waterman joined the firm, making it Joseph S. Waterman and Sons. Upon the death of Joseph Samson Waterman, his sons continued as partners in the firm. They were active when the firm was incorporated at the dawn of the 20th century and is now one of the oldest corporations in the country. The firm is known today as J. S. Waterman and Sons-Waring. (Author's collection.)

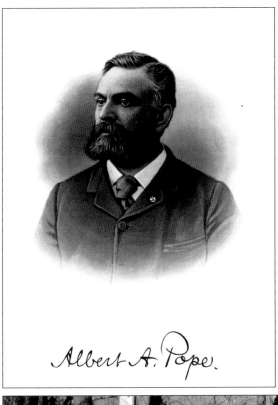

Albert Augustus Pope (1843–1909) was the founder of the Pope Manufacturing Company, which produced the immensely popular Columbia bicycle. Pope was an advocate for bicycles in Victorian America and sponsored races and the Boston Bicycle Club. He diversified into automobile production. His automobile was known as the Pope Motor Carriage, and his business was later renamed the Colombia Automobile Company. He was also an advocate for improved roads and came be called the "father of good roads." (Author's collection.)

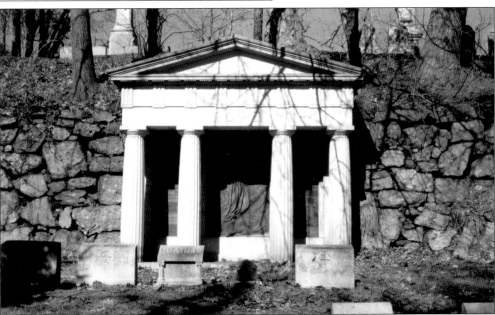

The Pope monument was designed by the Boston architectural firm of Dwight and Chandler. It was built in 1896 as a classical temple front with four granite Doric columns supporting a pediment and set against a stone embankment wall. The classically inspired monument has a large bronze tablet of a whispering ethereal angel set into the wall flanked by family names (Author's collection.)

The Taylor family lot on White Oak Avenue is dominated by a large hammered stone with a bronze tablet to Charles H. Taylor and Georgianna Davis Taylor. On either side of the lot are upright limestone crosses for members of the Taylor family, all of which are encircled by large mature rhododendrons. (Author's collection.)

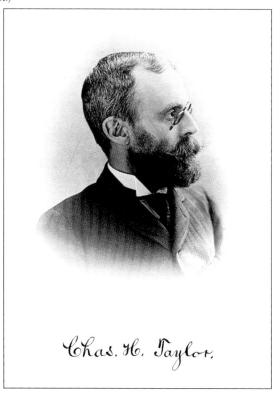

Gen. Charles H. Taylor (1846–1921) was a veteran of the Civil War, having served in the 38th Massachusetts Regiment. After working as a reporter for a few years, he purchased the *Boston Globe* in 1877, which was founded five years before, and set about creating the ideal of the modern newspaper of the Victorian era. Taylor had served as a member of the Massachusetts House of Representatives and as editor and publisher of the newspaper, which included three generations of his family. (Author's collection.)

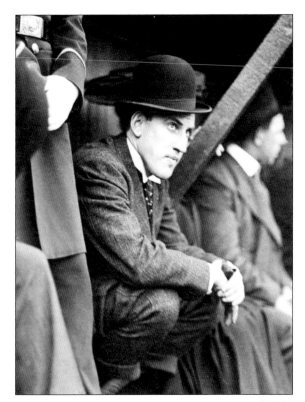

John Irving Taylor (1875–1938) was a onetime owner of the Boston Red Sox. He built Fenway Park, which opened in 1912 and has for almost a century been home to the baseball team he did so much to promote. Taylor, son of *Boston Globe* publisher Charles H. Taylor, owned the Boston American League team from 1904 to 1911. While the team did not win the World Series under his direction, he renamed the team the Boston Red Sox in 1907. (Courtesy of the Boston Public Library.)

M. Steinert and Sons was founded in 1860 by Morris Steinert (1831–1912), a native of Bavaria who opened a music store in Boston in 1880 and had two piano factories, one in Boston and the other in Worcester. Steinert Hall was designed by Winslow and Wetherell and built in 1892 in Boston. It is the oldest retail music location in the United States. (Author's collection.)

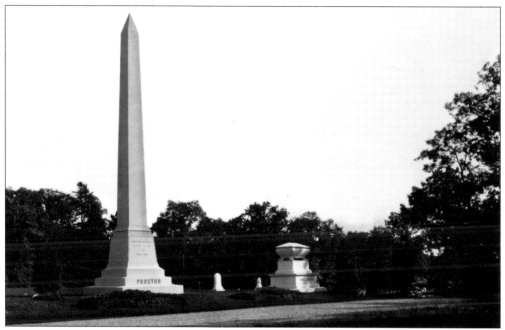

Beside the Proctor family obelisk on Summit Avenue is the cenotaph monument of Eben Dyer Jordan (1822–1895). The soaring obelisk of Thomas Emerson Proctor (1834–1894) commands the area of Milton Hill and reflects the influence of ancient Egypt. The sarcophagus-like memorial to Jordan reflects the classicism of ancient Rome.

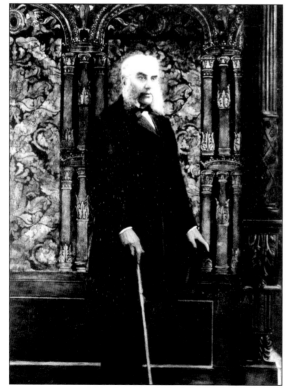

In 1851, Jordan and his partner, Benjamin L. Marsh, started the fancy dry goods store known as Jordan Marsh and Company, which grew into one of the largest department store chains in New England. Jordan Marsh and Company, with its flagship store located in Downtown Crossing, was beloved to Bostonians, but in 1996, it was absorbed by the New York–based Macy's, which was founded by Rowland Macy in Boston prior to the Civil War. (Author's collection.)

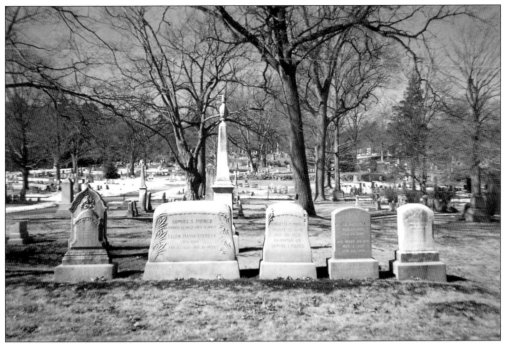

The Pierce family lot is on Poplar Avenue adjacent to the Wallis family lot. S. S. Pierce's wife was Ellen Maria Theresa Wallis (1812–1895), and her family lived in Jamaica Plain. The lot has individual headstones and doubles for couples. (Author's collection.)

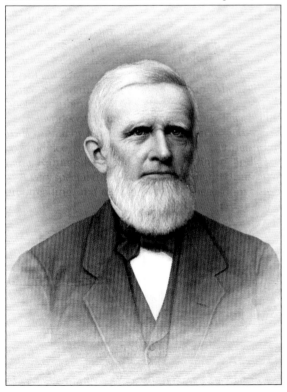

Samuel Stillman Pierce (1807–1880) was known as the purveyor of fancy goods and libations to Victorian Bostonians. Opening his store in the old west end of Boston in 1831, he catered to the carriage trade and created a company that involved four generations of the Pierce family in its successful operations. As a businessman, Pierce was said to be "a man of unflinching honesty and sterling integrity of character." (Author's collection.)

Oliver Ditson (1811–1888) was one of this country's most successful music publishers in the Victorian period. The Oliver Ditson Company published "a wider variety of music, music journals, and music education books than had ever before been available." Following Ditson's death, his music publishing company continued unabated until 1937 when it was purchased by Theodore Presser in Philadelphia. (Author's collection.)

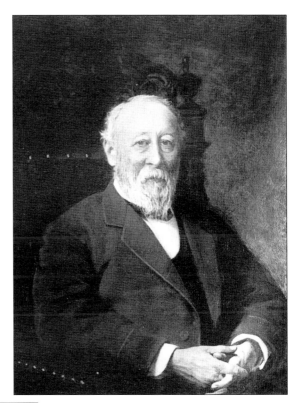

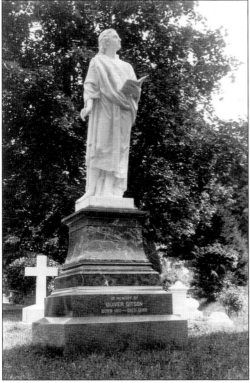

St John the Evangelist was sculpted by Thomas Ball (1819–1911) in 1873 and placed on the Ditson family lot. Ball was a well-known sculptor, and his equestrian statue of Gen. George Washington was erected in 1869 in the Boston Public Garden, facing the Commonwealth Avenue mall.

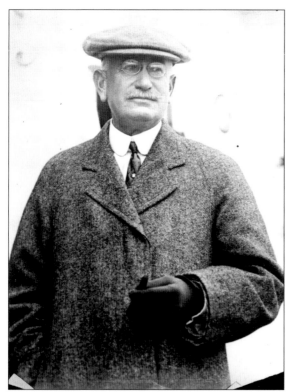

Eben Dyer Jordan Jr. (1857–1916) became a partner in his father's store, Jordan Marsh, in 1880 and president of the company in 1895. Although he continued to expand and promote his family's department store, he was best known for promoting the Boston Opera House and building the Fenway Studios on Ipswich Street for artists. Jordan served as president of Jordan Marsh Company, the Boston Opera Company, and the New England Conservatory of Music, where Jordan Hall was named in his honor.

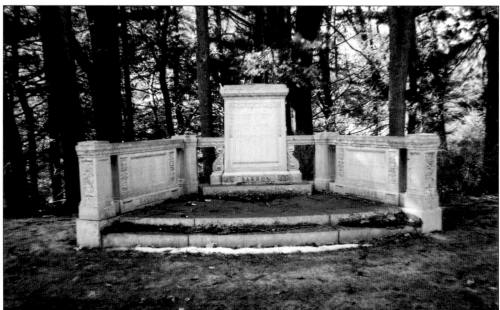

Clarence Walker Barron (1855–1928) was considered to be the father of modern financial analysis and writer and consultant on international finances and their impact on government and war. As a journalist with local newspapers, he founded the Boston News Bureau. He acquired the Philadelphia News Service, Dow-Jones interests in New York, and the *Wall Street Journal*. *Barron's* magazine still bears this financial wizard's prominent name. (Author's collection.)

Orlando H. Davenport (1830–1915) was associated with the publishing firm of Sampson, Davenport and Company in Boston. He was publisher of the *Boston Directory*, which had been published annually since 1789 and listed Boston professionals. (Author's collection.)

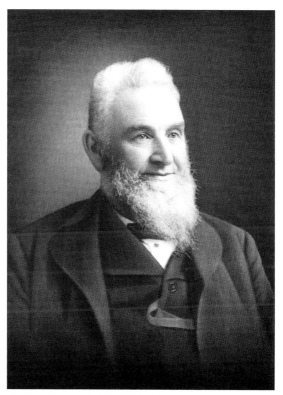

The Davenport monument is one of the grandest Victorian memorials at Forest Hills Cemetery, with an almost churchlike spire surmounting the granite pile. A female statue gazing towards the heavens and clasping a cross to her breast is enclosed in a baldicchino that surmounts an enormous granite base.

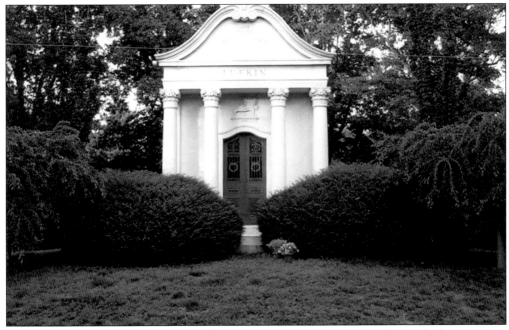

The Lufkin mausoleum was erected in 1928. It is not only a place of burial, but it also has a granite carving above the entrance that reads, "The inventor of the first Vamp Folding Machine," and a three-dimensional carving of the device with the patent date of 1877. (Author's collection.)

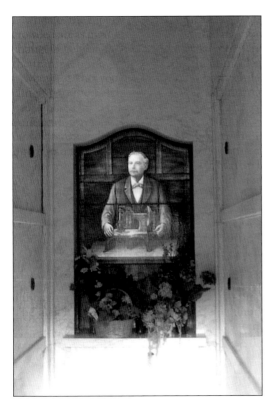

Richard H. Lufkin (1851–1922) was the inventor in 1877 of the vamp folding machine that revolutionized the American shoe industry. A diploma from the Massachusetts Charitable Mechanics Association stated that this "is a well-known and meritorious machine and is standard among shoe manufacturers. It is unrivalled and is in use in all parts of the country and also abroad." This likeness of Lufkin, complete with his 22-pound vamp folding machine, is in stained glass in his mausoleum.

The lot of William Pope is one of the few to retain its cast-iron fencing, complete with an arbor-entwined arch and a weeping willow on the gate. The large, white, marble obelisk commemorates one of the early merchants of Dorchester that cut and shipped lumber from Machias, Maine, to Dorchester and later established a branch in San Francisco in the mid-19th century. (Author's collection.)

The Curtis family lot has a soaring granite obelisk that marks the spot of George Curtis (1817–1898) and Martha Ann Upton Curtis (1826–1894). Curtis Hall in Jamaica Plain was the former town hall of West Roxbury, which separated from Roxbury in 1851. The hall was given by the Curtis family on land they generously donated to the town. Today it is used as the Jamaica Plain Community Center.

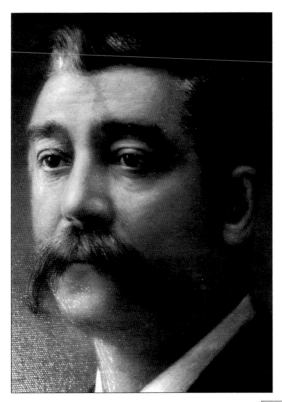

Jacob Wirth (1840–1892) was an immigrant from Kreuznach, Prussia, who six years after he immigrated to America opened his namesake Germanic beer hall–style restaurant on Stuart Street in Boston in 1868. Above the long mahogany bar is the Latin motto *Suum Cuiqce*, which literally translates as, "to each his own" and aptly fits the character of this legendary restaurant. (Courtesy of the Jacob Wirth Restaurant.)

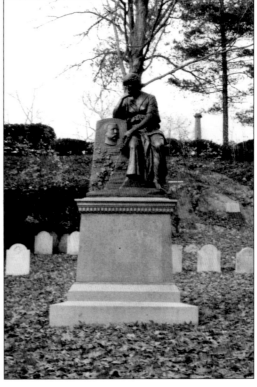

The Jacob Wirth memorial *Fame* was sculpted by Adolph Robert Kraus. This bronze monument is of a pensively draped, allegorical, seated figure contemplating a cameo portrait of the famous restaurateur in the stele below. The monument was cleaned in 1997 through the generosity of the Fitzgerald family, who, in 1975, had bought the then century-old Jacob Wirth Restaurant. (Author's collection.)

Henry J. Pfaff (1826–1893) was a well-known lager beer brewer whose brewery was active from 1857 to 1918 and was located at 1276 Columbus Avenue, the present site of Roxbury Community College. With his brother, Pfaff established the H and J Pfaff Brewery, which imparted a little bit of old Germany and created the demand for the new German-type lager beers. (Author's collection.)

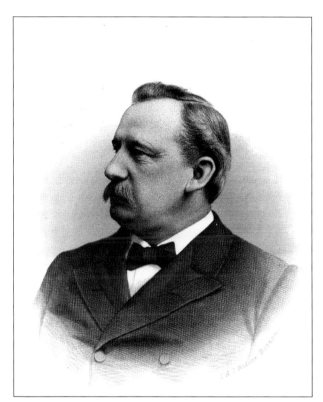

The Pfaff mausoleum was designed by Whitman and Howard and is an impressive Egyptian Revival granite mausoleum. The use of Egyptian Revival architecture for a memorial is something that was popular throughout the 19th century, as it represented an ancient culture that was devoted to the afterlife and reverence for the dead. (Author's collection.)

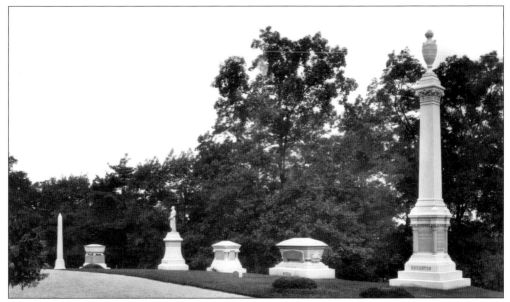

An impressive array of late-19th-century funeral monuments is aligned on Magnolia Avenue. On the far right is the monument of Andrew Jackson Houghton (1830–1892), the founder of Houghton and Company, which produced Vienna lager from an authentic German recipe. The lighter German and Austrian lager beers had come into favor just prior to the Civil War, displacing the once-popular heavier ales. Besides Vienna Lager, they made Pavonia Lager Beer, Vienna Old Time Lager, and Rockland Ale.

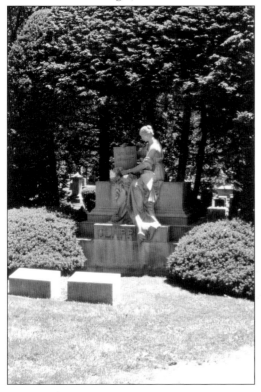

The Clapp monument depicts a seated classical figure holding a plaque declaring, "Life More Abundant," which might be explained in the quote from the Bible, "I have come that they might have life, and have it to the full," John 10:10. The figure is clad in a diaphanous gown that swirls around her body, and in her left hand, she holds a bouquet of flowers. Charles M. Clapp (1834–1897) was president of the Aetna Rubber Mill in Jamaica Plain and served as a trustee of Forest Hills Cemetery (Author's collection.)

Seven

THE 20TH CENTURY

Where there is sorrow there is Holy ground.

—Oscar Wilde

By the late 19th century, the once open lands at Forest Hills Cemetery were being developed, for both family lots as well as individual graves. With the purchase of Milton Hill from William F. Milton, the area was connected to Consecration Hill by a stone bridge, designed by William Gibbons Preston, which arched over Greenwood Avenue. The area of Milton Hill was to be developed in the first three decades of the 20th century, and has a rich overlay of funereal monument styles, from classical to Grecian, Egyptian, and romantic influenced designs which embraced the wide spectrum of available choices.

The early curvilinear avenues were augmented by new ones laid out connecting parts of the original cemetery to areas by Walk Hill and Canterbury Streets and west of the Field of Manoah. These new areas had a rich panoply of funereal stones, from colonial revival slate headstones to large limestone, marble and granite monuments often with angels, allegorical figures, and classical urns, vases, and other embellishments. The 20th century also saw some spectacular mausoleums that were built throughout the cemetery, such as the Lufkin, Wilbur, Thym, Martyn, Hanley, and Haste mausoleums.

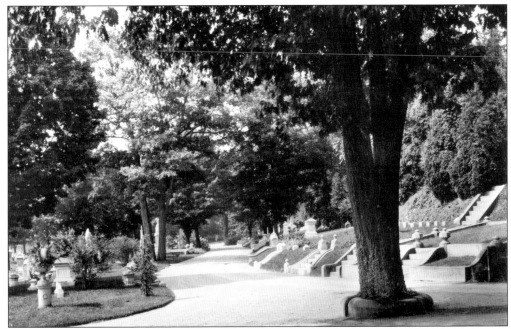

Rock Maple Avenue, seen from the junction of Cedar and Tupelo Avenues, has terraced lots on the right with granite curbing and flights of stairs leading to the large family graves. These curbed lots with granite balusters created a distinctively urban feel, almost recreating the urban residential streetscapes of Victorian Boston.

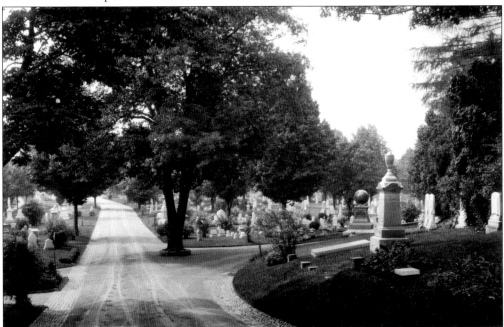

Looking south toward Cedar Avenue, the lots, seen on the right, were laid out with such names as Peony, Evergreen, Elder, Brook, Arethusa, Pyrola, Mimosa, Camellia, and Veronica Paths. These lots have a wide variety of monuments made of varying heights, designs, and materials, making it visually interesting.

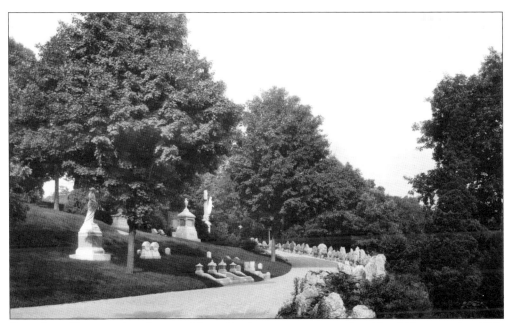

Seen from Consecration Avenue, Magnolia Avenue curves up the side of Consecration Hill. The right edge of the avenue has a dramatic rockery of sharply irregular pieces of Roxbury puddingstone set on end that not only creates a visually interesting border but also acts as an embankment where the land sharply slopes down to Bittersweet Path and overlooks the Gardens of Devotion, Enduring Love, and Meditation.

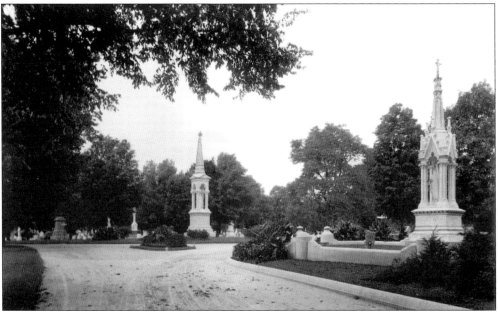

Lake Avenue on the left parallels Lake Hibiscus and has two of the more impressive Victorian monuments on opposite corners. In the center is the impressive spirelike Davenport monument of Orlando H. Davenport (1830–1915), publisher of the *Boston Directory*. On the right is the Gothic-inspired marble memorial to one-time tailor and major philanthropist Andrew Carney. Carney founded the Caritas Carney Hospital in 1863.

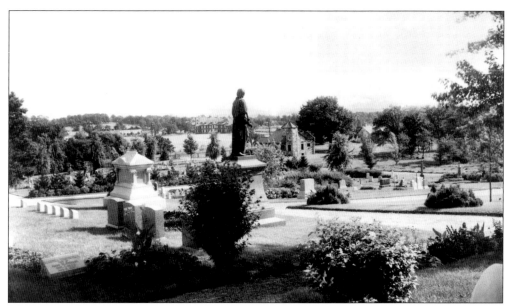

This vista, looking south from Elm Avenue, shows the stone Canterbury Street Lodge in the center distance at the Canterbury Street gate. The open lands on the left later became St. Michael's Cemetery, and to the left of the statue in the center are the buildings designed by Edmund March Wheelwright (1854–1912) on Austin Farm. In the center is the statue monument on the grave of George B. Smith (1868–1949), and on the left is that of Nathan Sawyer (1819–1889).

The Field of Heth is a large single-grave section in the area of Forest Hills Cemetery bounded by Hackmatack and Thorn Avenues. Laid out in 1864, it was primarily for people who did not wish to purchase large family lots. In the distance is the side elevation of the Canterbury Street lodge. At center right are the headstones of Samuel Boyle Reid (1869–1937) and Herman A. Flick (1866–1897).

114

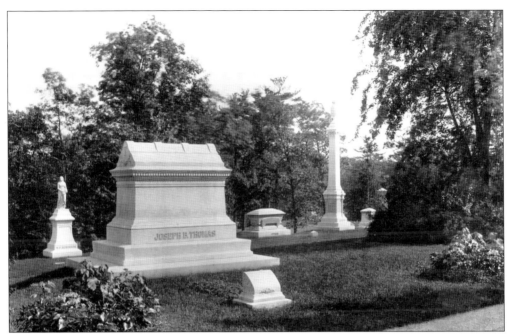

Magnolia Avenue, between Oakland Avenue and the stone bridge on the right, is at the crest of Consecration Hill and has an oval in the center with the memorial to Joseph B. Thomas (1811–1891). An enormous limestone houselike memorial replete with a pediment roof, it is flanked by the Robertson memorial on the left and the Pitkin and Houghton memorials on the right.

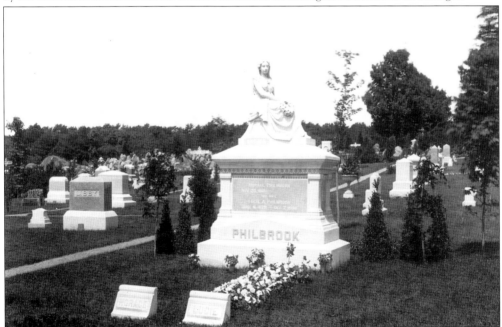

The Philbrook memorial is a large granite block monument with corner pilasters supporting a beveled base for an allegorical figure of a seated woman holding a wreath marked "Lucie." Horace Philbrook (1819–1904) erected this monument on Pearl Avenue to the memory of his late wife, Lucie A. Philbrook (1929–1900).

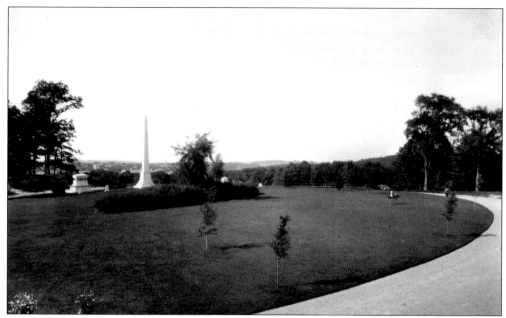

Consecration Hill, once part of the farm of William F. Milton (1837–1905), was purchased by Forest Hills Cemetery in 1890. Milton Hill was developed and landscaped with concentric roads and planted with trees and lavish evergreens. Hillside Avenue, which encircles the central knoll, is seen with the soaring obelisk of Thomas Emerson Proctor (1834–1894), and to the left is the sarcophagus-like memorial to Eben Dyer Jordan.

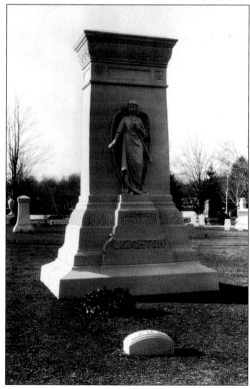

The Leighton family memorial is a large granite monument on Lake View Avenue. John William Leighton (1825–1897) chose a large monument with an angel on the front. On the left are the memorial to George W. Colby (1830–1903) and the Larabee family urn.

116

Eight

FOREST HILLS
EDUCATIONAL TRUST

Safe in the hallowed quiets of the past.

—Lowell

The Forest Hills Educational Trust is a nonprofit organization founded in 1991 to preserve, enhance, interpret, and celebrate Forest Hills Cemetery. The trust organizes a variety of programs inspired by the cemetery's unique environment—walking tours, concerts, poetry readings, a summer camp program, and adventurous exhibitions of contemporary art as well as ceremonies of remembrance. These activities are designed to invite the community to explore one of the city's treasures. At first, many people are surprised to find so much happening in a cemetery. However, they quickly realize that Forest Hills is an extraordinary resource, a place to experience art, nature, and history as well as a tranquil sanctuary for reflection and remembrance

The trust's expert tour guides give visitors a glimpse of the history of Boston through the stories of the people buried at Forest Hills. Other tours reveal the meaning of the symbols carved in stone memorials—oak leaves for strength, ivy for a faithful nature—and stop at bronze and marble sculpture by the most eminent artists of the 19th and early 20th century; the trust raises funds to engage conservators every year to care for some of these endangered masterpieces, which are damaged by pollution and New England weather. The Lantern Festival and a traditional Day of the Dead are major community events that draw thousands every year; the beauty and spirituality of Forest Hills make it an inspiring setting to gather and celebrate the memory of family and friends. The trust's exhibitions of contemporary art offer new ways to think about age-old themes of family, ancestors, nature, remembrance, the cycles of life, and the world of the spirits. These programs are extremely innovative and have become a national model; however, the trust is working to restore the original vision of the cemetery as a destination—a welcoming place for the living as well as an eternal home for the dead.

The *Ritual Trees* series relies on the hand as both image and tool. Unprotected by clothing, the bare hand connects people to the world through touch. Charles McQuillen, the artist, said that he was "struck by the layers of history this landscape records, how the dated gravestones and monuments chronicle individual histories, how the old stone walls and mature plantings thick with age bear witness to the seasonal rites that have shaped the land. Signs of life's ebb and flow are everywhere."

Mitch Ryerson, seen kneeling on the left, created *Poetry Chairs* of wood and copper during an artist-in-residence program with students and teachers from the Little House School in Dorchester and the assistance of noted poet Elizabeth Mc Kim. The chairs, which allow the sitter to lounge, were crafted from large pieces of wood cut from tree trunks at Forest Hills Cemetery and have poetry by the students stamped onto the copper seats.

Elise Ciregna, curator of Forest Hills Cemetery, often gives walking tours extolling the importance of its 19th-century sculpture and the iconography of its headstones. Here she points out the white marble headstone of Hosea Fisk (died 1858), which is carved with a gathered swag and a central tassel that replicates Victorian window treatments of the mid-19th century. Ciregna states that Fisk's widow probably "wanted to emphasize that domesticity and respectability were important qualities she and her husband shared."

Al Maze stops on White Pine Avenue to discuss the elaborately carved white marble monument of Lucy Bixby (1818–1864) whose portrait was carved within an angel-surmounted wreath of marble flowers. Bixby is shown as a woman who was virtuous and pious, receiving a crown, a sign of resurrection, the highest award possible for a departed soul, with ivy, roses, and lilies surrounding her face, each of the three signifying fidelity, love, and resurrection.

Schoolchildren and summer campers often are treated to special walking tours at Forest Hills Cemetery, with not just monuments and cemetery history being offered but also a day in a verdant parklike atmosphere with mature trees and lush rolling lawns. Here a group of attentive children listen as a tour guide describes the importance of the soldiers' monument, known as *Citizen Soldier*, which was sculpted by Martin Milmore and erected in 1867 by the city of Roxbury to commemorate its fallen dead who served during the Civil War.

The perennially popular dog walk brings historically interested canines and their well-behaved owners to participate in a tour of the cemetery that includes visits to such places as the Barnard lot. A dog rests in front of a large Newfoundland dog that marks the graves of Henry Barnard (1810–1853) and Lucretia Barnard (1813–1913), which was sculpted by Henry Dexter. Since ancient times, loyal dogs guarded their master's graves, protecting them and keeping them company in the afterlife.

The Forest Hills Educational Trust also helps to conserve the many diverse monuments that characterize the importance of the cemetery. Here, Jean-Louis Lachevre cleans the nationally important *Death Staying the Hand of the Sculptor* by Daniel Chester French. Created to memorialize fellow artist Martin Milmore, it shows him as a youthful sculptor carving the sphinx at Mount Auburn Cemetery, which was dedicated to the "preservation of the American Union" during the Civil War. Moved to its present site in 1943, its setting was designed by noted father and son landscape architects Arthur and Sidney Shurcliff.

Adam Osgood, assistant to Lachevre, cleans the bronze sculpture *The Sentinel* by local artist Fern Cunningham. Set atop an outcropping of Roxbury puddingstone, the sculpture was cast in 2003 and represents "the wise old woman of Africa" and Cunningham's interest in themes involving humanistic ideals, particularly those of women and children. The casting of this sculpture was supported by a grant from the George B. Henderson Foundation.

The annual Lantern Festival attracts thousands of Bostonians every July when they come to picnic, socialize, and enjoy music and dance before lanterns are launched on Lake Hibiscus at dusk. The festival is inspired by Buddhist traditions and is an intensely moving nondenominational ceremony. Here, Japanese performers participate in this ceremony, as people from all walks of life look on.

Dancers weave both color and design through the air with long bolts of fabric as they move to music that memorializes the dead during the annual Lantern Festival. Dancers, musicians, and many others come together to remember and to memorialize the dead in this unique and embracing ceremony, which creates a sense of inclusion for all who come to Forest Hills Cemetery, regardless of their faith, creed, or ethnicity.

Attendees at the Lantern Festival are able to memorialize deceased family and friends by parchment lanterns that can be individualized with names, poems, and messages. These lanterns, wood bases with four pegs to secure the parchment, are a way to reflect and remember, and even if one's departed is not buried at Forest Hills Cemetery, it is a way to connect and remember.

Two young women kneel at the edge of Lake Hibiscus to launch their lantern, with Chinese characters memorializing a departed loved one. Thousands of individualized lanterns are set afloat as the ethereal sound of "Auld Lang Sine" is played by a lone, unseen bagpiper. This intensely moving ceremony has increased in attendance every year since its inception over a decade ago and creates a magical evening by which people can remember loved ones.

Three young friends stand between *Spirit Houses* by artist Laura Baring-Gould. The artist's work originates from the belief that understandings of place, culture, and collaborative potential satisfy deep and buoyant needs and that art employs elemental materials and archetypal forms in ways that catalyze memory and awareness. In the distance is the granite Greek Revival mausoleum of Frank E. Wilbur.

A *Place to Stay* was created by artists Michael Beatty and Mike Newby from painted steel, wood, and copper. The artists said, "Our birdhouses rework the architectural motifs of the cemetery and provide shelter for its living, breathing, animated residents. By manipulating mass and volume in the construction of the supporting framework, we aim to integrate a sense of the traditional with a new, deconstructed model."

The shroudlike stainless-steel screen sculptures by Leslie Wilcox envelop tall, slender trees as children touring the contemporary art walk inspect the sculptures. *Nightshirts* has a gentle quality, evoking a Victorian family, which seemingly has returned to the world of the living for a brief visit. Wilcox said, "It seems as if a group of figures almost flies above the fray, looking down at us as we look up at them."

Assisting in the affixing of shards of pottery to a large obelisk are a group of children with artist Danielle Krcmar, who worked in collaboration with Derek Brain in 2004 on *Things Worth Remembering*. The primary mosaic material was china shards collected at Carson Beach in Dorchester, which represent domestic fragments and give a glimpse of many personal histories and connections, now lost.

Almost like steps leading to the grave of poet E. E. Cummings, pine boards with black paint were placed in 2004 by Caroline Bagenal and called *Poems*. The complex union of the visual and aural in Cummings's poetry, along with his strong sense of design and unconventional use of typography, and his playful placement of words across the page all suggested a sculptural interpretation. The artist said, "I was interested in transforming the poems into objects that engage us physically as we move around them."

A circling, undulating weave of locally gathered sticks seems to cascade down a slope enveloping boulders and Roxbury puddingstone in the process. *Lethe* is a man-made form, which was woven in 2003 by artist Frank Vasello as a natural landscape. It evokes the motion of a river cutting through rock before swirling back into the earth. By using the detritus of nature, this installation gave new life and meaning to dead cast-offs that were collected throughout Forest Hills Cemetery.

A group of enthusiastic children stop in front of *Opening*, carved in 2002 by sculptor and woodworker Mitch Ryerson from a 10-foot-tall sugar maple tree trunk. The lancet arched opening is a sculptural work that has a bronze floor engraved with some of the poetry of E. E. Cummings, which represents part shelter and part passageway, seemingly from the present life to the afterlife.

Artist Christopher Frost created *Neighbors*, cast concrete replicas of the temporal homes of some of Forest Hills Cemetery's permanent residents. These small houses are perched atop a sloping hillside of Roxbury puddingstone. The artist said, "I chose structures from the thousands of possible residences in order to include a variety of architectural styles. Just as the houses' architecture reflected the diversity of their occupants' background, social status, ethnicity, and other traits during their lifetimes, so the architecture of their monuments and grave sites reflects those traits after their deaths."

ACROSS AMERICA, PEOPLE ARE DISCOVERING SOMETHING WONDERFUL. *THEIR HERITAGE.*

Arcadia Publishing is the leading local history publisher in the United States. With more than 3,000 titles in print and hundreds of new titles released every year, Arcadia has extensive specialized experience chronicling the history of communities and celebrating America's hidden stories, bringing to life the people, places, and events from the past. To discover the history of other communities across the nation, please visit:

www.arcadiapublishing.com

Customized search tools allow you to find regional history books about the town where you grew up, the cities where your friends and family live, the town where your parents met, or even that retirement spot you've been dreaming about.